NOTES

ON

MECHANICAL DRAWING

PREPARED FOR THE USE OF
STUDENTS IN

MECHANICAL, ELECTRICAL AND CHEMICAL ENGINEERING

BY
HORACE P. FRY, B. S. in E. E.
ASST. PROF. OF MECHANICAL DRAWING

Copyright © 2013 Read Books Ltd.
This book is copyright and may not be
reproduced or copied in any way without
the express permission of the publisher in writing

British Library Cataloguing-in-Publication Data
A catalogue record for this book is available from the
British Library

Technical Drawing and Drafting

Technical drawing, also known as 'drafting' or 'draughting', is the act and discipline of composing plans that visually communicate how something functions or is to be constructed.

It is essential for communicating ideas in industry, architecture and engineering. The need for precise communication in the preparation of a functional document distinguishes technical drawing from the expressive drawing of the visual arts. Whereas artistic drawings are subjectively interpreted, with multiply determined meanings, technical drawings generally have only one intended meaning. To make the drawings easier to understand, practitioners use familiar symbols, perspectives, units of measurement, notation systems, visual styles, and page layout. Together, such conventions constitute a visual language, and help to ensure that the drawing is unambiguous and relatively easy to understand.

There are many methods of constructing a technical drawing, and most simple among them is a sketch. A sketch is a quickly executed, freehand drawing that is not intended as a finished work. In general, sketching is a quick way to record an idea for later use, and architects sketches in particular (in a very similar manner to fine artists) serve as a way to try out different ideas and establish a composition before undertaking more finished work. Architects drawings can also be used to convince clients of the merits of a design, to enable a building constructer to use them, and as a record

of completed work. In a similar manner to engineering (and all other technical drawings), there is a set of conventions (i.e particular views, measurements, scales, and cross-referencing) that are utilised.

As opposed to free-sketching, technical drawings usually utilise various manuals and instruments. The basic drafting procedure is to place a piece of paper (or other material) on a smooth surface with right-angle corners and straight sides – typically a drawing board. A sliding straightedge known as a 'T-square' is then placed on one of the sides, allowing it to be slid across the side of the table, and over the surface of the paper. Parallel lines can be drawn simply by moving the T-square and running a pencil along the edge, as well as holding devices such as set squares or triangles. Other tools can be used to draw curves and circles, and primary among these are the compasses, used for drawing simple arcs and circles. Drafting templates are also utilised in cases where the drafter has to create recurring objects in a drawing – a massive time-saving development.

This basic drafting system requires an accurate table and constant attention to the positioning of the tools. A common error is to allow the triangles to push the top of the T-square down slightly, thereby throwing off all the angles. Even tasks as simple as drawing two angled lines meeting at a point require a number of moves of the T-square and triangles, and in general drafting this can be a time consuming process. In addition to the mastery of the mechanics of drawing lines, arcs, circles (and text) onto a piece of paper – the drafting effort requires a thorough understanding of geometry, trigonometry and spatial

comprehension. In all cases, it demands precision and accuracy, and attention to detail.

Conventionally, drawings were made in ink on paper or a similar material, and any copies required had to be laboriously made by hand. The twentieth century saw a shift to drawing on tracing paper, so that mechanical copies could be run off efficiently. This was a substantial development in the drafting process – only eclipsed in the twenty-first century with 'computer-aided-drawing' systems (CAD). Although classical draftsmen and women are still in high demand, the mechanics of the drafting task have largely been automated and accelerated through the use of such systems. The development of the computer had a major impact on the methods used to design and create technical drawings, making manual drawing almost obsolete, and opening up new possibilities of form using organic shapes and complex geometry.

Today, there are two types of computer-aided design systems used for the production of technical drawings; two dimensions ('2D') and three dimensions ('3D'). 2D CAD systems such as AutoCAD or MicroStation have largely replaced the paper drawing discipline. Lines, circles, arcs and curves are all created within the software. It is down to the technical drawing skill of the user to produce the drawing – though this method does allow for the making of numerous revisions, and modifications of original designs. 3D CAD systems such as Autodesk Inventor or SolidWorks first produce the geometry of the part, and the technical drawing comes from user defined views of the part. This means there is little scope for error once the parameters have been set.

Buildings, Aircraft, ships and cars are now all modelled, assembled and checked in 3D before technical drawings are released for manufacture.

Technical drawing is a skill that is essential for so many industries and endeavours, allowing complex ideas and designs to become reality. It is hoped that the current reader enjoys this book on the subject.

PREFACE.

Mechanical drawings are required in all constructive work. In making such drawings, strict adherence to the principles of projection, accuracy and neatness in execution remove all doubts as to what is intended and makes a drawing perfectly clear to all accustomed to reading them.

The matter contained in these notes is not an exhaustive treatise on mechanical drawing, but is intended to supplement the class instruction and should be referred to constantly by the student in his work.

These notes contain recognized standards and conventions used in American practice, together with tables and other information valuable on the drawing table. The student will be held responsible for his work being done as directed in these notes.

Questions are continually arising in the student's mind as to just how to represent certain conditions, and it is his duty to answer these questions for himself by referring to these notes before questioning the instructor, as the latter's time should be given to personal supervision of the work each student has in hand.

All drawings, when completed and handed in, will be examined for execution, projection, arrangement and numerical errors, and any corrections required will be marked in pencil by the checker. Attention is called to the errors by means of the paragraph numbers under the subjects. The student must make corrections, or a new drawing, before the work will be finally accepted. Redrawn or corrected drawings must be returned not later than the return date stamped on the margin.

Drawings, tracings and all other papers handed in by the student must bear his locker number with his name under it in the extreme upper right-hand corner, using neatly printed letters and figures $\frac{3}{16}''$ high. On drawings and tracings these should be placed on the long margin. See forms under Size of Sheets.

THE COURSES IN DRAWING.

The work in drawing extends over four years and is divided as follows:

FRESHMAN COURSE—492. Copying simple drawings accurately to familiarize the student with the handling and uses of the instruments. The principles of Orthographic Projection. Making simple mechanical working drawings from blue prints of free-hand sketches. Sectioning and shading. Free-hand lettering.

SOPHOMORE COURSE—493. First Term. Making more intricate working drawings from free-hand sketches. Tinting. Tracing.

Second Term. Making working sketches on cross-section paper from parts of machinery in the laboratory, the dimension of the parts to be found by measurement, the only tools being pencil, two-foot rule and calipers.

JUNIOR COURSE—494. First Term. Making detail and assembly working drawings from sketches made by the student in the previous course (493). Tracing and blue-printing the same.

Second Term. Constructing combinations of mechanism, with restrictions, from data furnished and making drawings of the same, exact calculations for strength being a secondary consideration, the parts being proportioned empirically, the primary considerations entering into the construction being those governed by the kinematic side of the proposition and the student's inventive ability.

SENIOR COURSE—517. Original sketches and calculations of the parts of some hoisting machine of an approved type, such as a crane, hoist, etc., are made by the student from which he must lay out an assembly drawing and detail working drawings and make tracings of them. In this course a student does individual work and is left largely to his own resources, his previous training being the main guide. The entire year is devoted to this subject.

INSTRUMENT LIST.

Each student will provide himself with the following articles before he will be allowed to begin his work:

A. Drawing instruments contained in set No. 2050 made by Theo. Alteneder & Sons, Philadelphia, as follows:

> No. 1404, $5\frac{1}{2}''$ compass, pen, pencil and lengthening bar, fixed needle point leg.
> No. 1530, $3\frac{1}{4}''$ bow spacer.
> No. 1532, $3\frac{1}{4}''$ bow pencil with needle point.
> No. 1533, $3\frac{1}{4}''$ bow pen with needle point.
> No. 1614, $5''$ ruling pen.
> Nickel-plated lead case.

The above to be contained in a morocco covered case having two metal hinges and clasps. (See Fig. 1.)

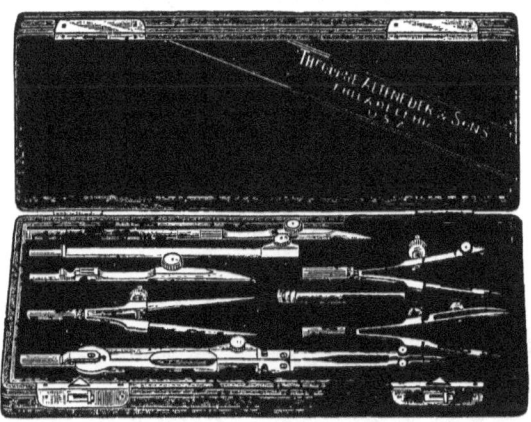

FIG. 1.

B. Triangular Box-wood scale having the following scales thereon: $12''$, $9''$, $6''$, $4''$, $3''$, $2''$, $1\frac{1}{2}''$ to the foot, and 50 parts to the inch divided the full length of the scale.
C. One $8''$—$45°$ celluloid triangle. Not less than $\frac{1}{16}''$ thick.
One $12''$—$60°$ celluloid triangle. Not less than $\frac{1}{16}''$ thick.

D. One celluloid irregular curve, as shown in Fig. 2. (K. and E. No. 19.)
E. T square, 30" blade (not set in head). Blade to have a celluloid edge.
F. Two 6H Kooh-i-noor or Castell drawing pencils.
G. One Faber's improved ink eraser (small).
One Faber's ruby pencil rubber (large).
One Art Gum cleaning rubber (large).
H. One dozen $\frac{3}{8}$" thumb tacks (thin head, K. & E. Ideal).
I. Drawing paper. (This can be purchased in the Department Supply Room 212.)
J. Reinhardt's Free-Hand Lettering, for Draftsmen, Engineers and Students.
K. Drawing board, exactly 23" x 31" with cleats on the back, face of board must not be shellacked. Each cleat to have a 3" x $\frac{3}{16}$" slot cut through next to board. Slots must be in line and about central of the cleats.
L. One bottle of black waterproof drawing ink. Higgins' or Steuber's.
M. One erasing shield. Must not be polished on both sides.
N. One drawing package (wallet, lettering paper, file, penholder, pens, inkrag), procurable in the Department Supply Room.

FIG. 2.

NOTE:—The above materials must be brought to the first session of the class in Course 492.

Every article itemized in the foregoing list has a specific purpose and must be used accordingly. (See Fig. 3 for use of triangles.)

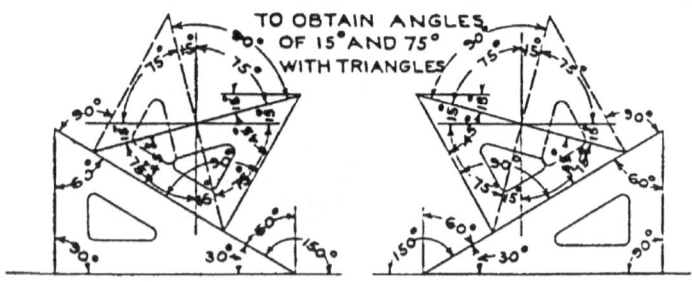

FIG. 3.

Chisel points must be used on all instrument leads and pencils. Cut the wood back for $1\frac{1}{4}$" exposing the lead for $\frac{3}{8}$", then flatten it by rubbing opposite sides on a file, then bring to a knife edge by using a slight rocking motion.

SIZE OF SHEETS. 1. All drawings required in Courses 492 and 493 are to be made on sheets 10″ x 14″, trimmed exactly to size. Complete the drawing before trimming it. For Forms see Course 492 and Course 493 below.

2. A number circle is to be placed in the lower left-hand corner of each drawing in Courses 492 and 493. The number of the sketch, from which the drawing was made, is to be placed in the upper half of the circle and the class section in the lower half as shown in Fig. 4.

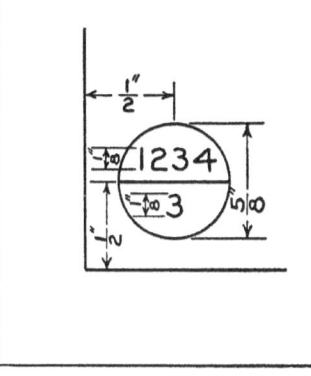

FIG. 4

3. Course 492.—First Term: Use the form shown in Fig. 5. For lettering on lower margin see Fig. 25.

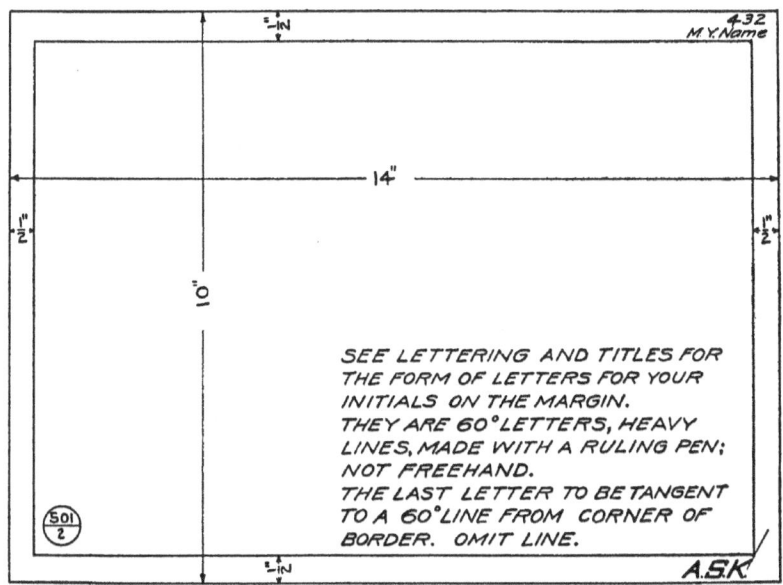

FIG. 5.

Fig. 6.

Course 492, Second Term } Use the form shown in Fig. 6.
Course 493, First Term
Course 493, Second Term. Sketching (see Figs. 26 and 27).
Course 494, First Term. Use Department standard sizes.
Course 494, Second Term. Use Department standard size A. See plate G for special form of title.
Course 517. Use Department standard size A, unless otherwise directed. See plate H for special form of title.

DEPARTMENT STANDARD SIZES. All drawings and tracings called for in any Department work, when trimmed, must be of one of the sizes shown in Fig. 7, unless specific orders to the contrary are given. Each tracing must have on the long margin, in the lower right and inverted in the upper left-hand corner, the letter indicating the size of sheet and the number of the drawing as assigned from the index. Block letters and figures $\frac{5}{8}''$ high are to be used for this notation. (See Fig. 24.) Index numbers will be assigned by the instructor when tracings are completed.

FIG. 7.

TRIMMING. Trim the drawings with a sharp penknife, using the **lower edge** of your **T square** as a guide and the **back of your drawing board** to cut on. **Never use the face of board or table top.** Trim tracing cloth with shears, leaving $\frac{1}{4}''$ outside of margin all around; trim to **size** after the tracings have been examined and corrections made. The corrections in pencil must not be erased.

Drawing sheets that are off size or carelessly trimmed or with thumb tack holes in the margin will be rejected.

THE ESSENTIALS. In making a mechanical drawing the essentials are accuracy, clearness and neatness, as the object of such a drawing is to enable one to make the part or combination picture, without any other information than that contained on the drawing. The workman constructs as the drawing shows, not as the draftsman may have intended to show.

ARRANGEMENT OF VIEWS. 1. All drawings are to be made as though the object were situated in the third angle and the views are to be arranged accordingly. (Faunce's Descriptive Geometry, Fig. 1.)

Assume the object, of which a drawing is to be made, to be surrounded by a glass box (see Fig. 8). In other words, the planes of projection are between the eye and the object in third angle projection. Suppose the object to be projected orthographically on

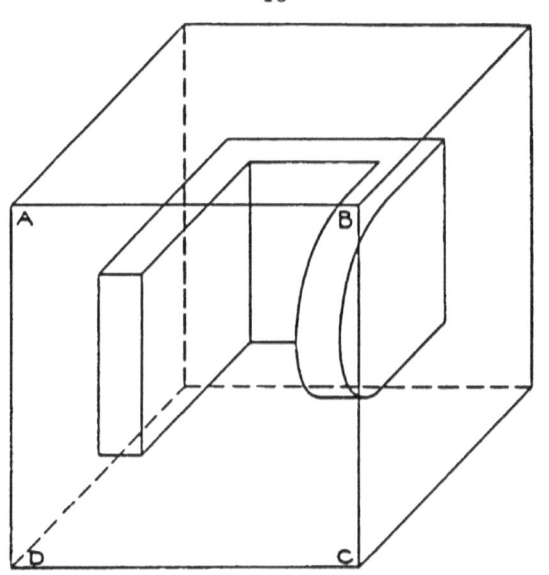

FIG. 8

each face of the box. Imagine one of the faces A B C D to coincide with the plane of the paper and revolve each of the others, about its intersection with that plane, until they are all in the plane of the paper, then the views will be in their proper relative position. The names and positions of the views thus projected are shown in Fig. 9.

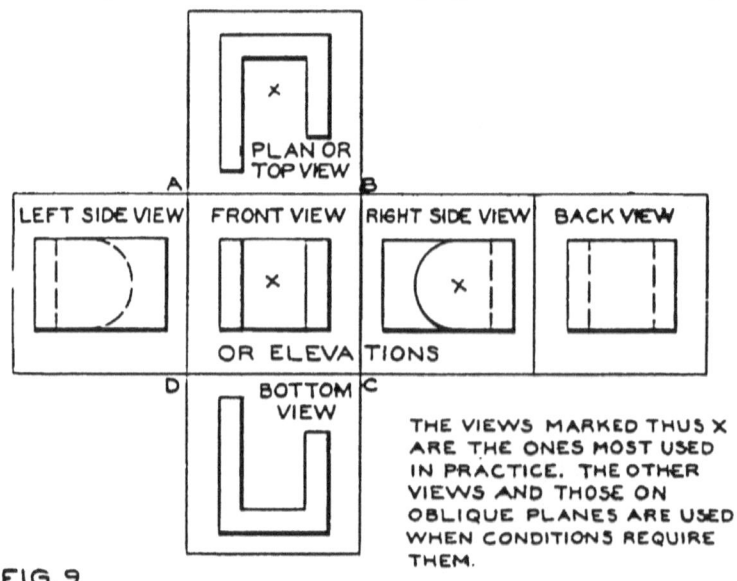

FIG. 9

THE VIEWS MARKED THUS X ARE THE ONES MOST USED IN PRACTICE. THE OTHER VIEWS AND THOSE ON OBLIQUE PLANES ARE USED WHEN CONDITIONS REQUIRE THEM.

CHOOSING THE PROPER SCALE. 1. Before beginning the drawing, decide what views are necessary to clearly show the object. The object should be drawn either full size (never larger) or 9", 6", 4", 3", 2", 1½", or 1" to the foot, the standard scales used in machine drawing.

2. Lay out the sheet so that the views, when properly placed, will leave room for the title. Move the views from the center of the paper rather than reduce the scale. The following method for determining the scale will generally be found convenient:

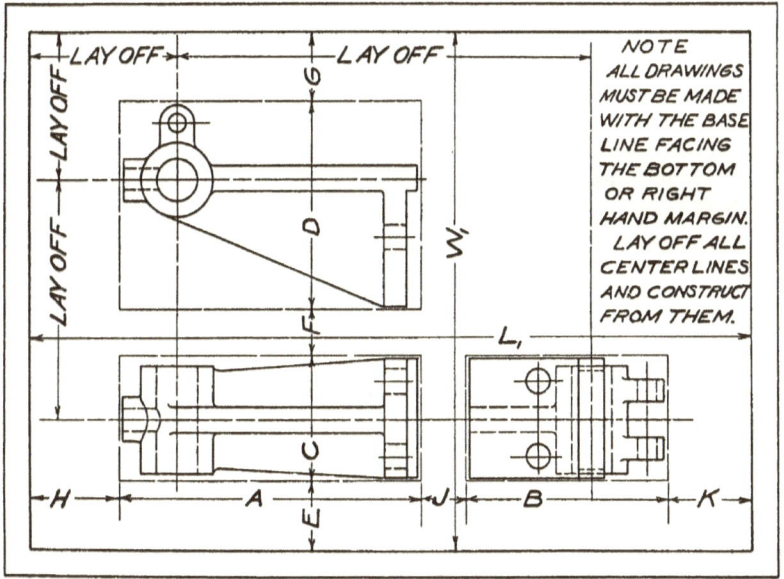

Fig. 10.

Suppose the rectangles in Fig. 10 to represent the least areas which will contain the different views desired. The dimensions of the rectangles being the overall dimensions of the object to be drawn. If $A+B<L_1$, the drawing can be made full size provided $C+D<W_1$. If not, multiply the dimensions (L_1 and W_1) of the paper by the quotient of 12 divided by one of the scales, 9, 6, 4, 3, 2 or 1½, on the Boxwood Scale, until the new $L_1>A+B$ and the new $W_1>C+D$. The scale that will give this is the **scale** to which the object can be drawn, or the reciprocal of the quotient is the **size** that the object can be drawn.

3. Never combine the words **size** and **scale**. Either **half size** or **scale** $6''=1'$; not **scale half size**.

4. The distance $L_1-(A+B)$ is to be divided between the spaces H, J and K as desired, and the distance $W_1-(C+D)$ is to be divided between the spaces E, F and G.

5. Make the distances (F and J) between the views not less than $\frac{1}{2}''$ or more than $1\frac{1}{2}''$, depending on the space required for dimensions.

The rectangles referred to are not to be used in the actual laying out of the views. **The center lines of each view are carefully located and from these the drawing is accurately constructed.**

LINES. 1. All drawings are to be made with a 6H sharp chisel pointed pencil and then inked with black India ink. **The pencil work is to be clear and distinct and have a finished appearance before the inking is done.** It is not necessary to pencil cross hatching or dimensions. The former may be done lightly freehand as a guide.

2. Full lines are drawn for all visible edges. See Fig. 11 for width of line.

3. Dotted lines are used to show hidden edges, and should

VISIBLE OR FULL LINE.
LIGHT LINE, RATIO 1 TO 3, SHADE LINE.

INVISIBLE OR DOTTED LINES.
BREAK JOINTS WHEN LINES ARE ADJACENT

CENTER LINE.

DIMENSION LINE.

CONSTRUCTION LINE.

IRREGULAR LINE.

FIG. 11.

be drawn when the clearness of the drawing is thereby furthered. (See Fig. 11.) These lines are in reality short dashes with spaces about $\frac{1}{4}$ the length of the dash. The first and last dash of a dotted line should touch the lines at which the hidden edge actually terminates. (See Fig. 12.)

THUS

NOT

FIG. 12.

4. When parallel dotted lines lie close together, stagger the dashes and spaces as shown in Fig. 11. The eye then can more readily follow the lines.

5. The full lines in the two views, Fig. 13, represent lines in full view, and the dotted lines hidden ones. If the drawing is too much complicated by showing all the hidden edges, some may be omitted, provided the clearness of the drawing is not impaired.

FIG. 13.

6. Center lines are long dash and dot black lines somewhat lighter than the outline. (See Fig. 11.) They are drawn through all axes of symmetry, the centers of all holes, bolts and rivets and where dimensions are to be given from some fixed line. The break should not occur where a line is crossed. (See Fig. 13.)

7. Different views of the same object are sometimes, though not necessarily, connected by center lines. (See Figs. 13 and 15.)

8. Irregular lines are used to denote a break when a portion of a view is shown in section. (See Figs. 11 and 15.)

9. Construction lines (see Fig. 11) are fine dash lines and are used largely in elementary work; they connect the projections on two adjacent planes. These lines should not touch the points between which they are drawn.

10. Adjacent part lines are drawn like construction lines. They are used to show a part that is adjacent to the piece drawn.

SHADE LINES. 1. To distinguish readily between depressed and raised portions of an object, and to make the drawings stand out, some of the lines are made heavy. The light is supposed to fall on all views of the object, from the upper left-hand corner of the drawing, in parallel rays, at an angle of 45° with the plane of

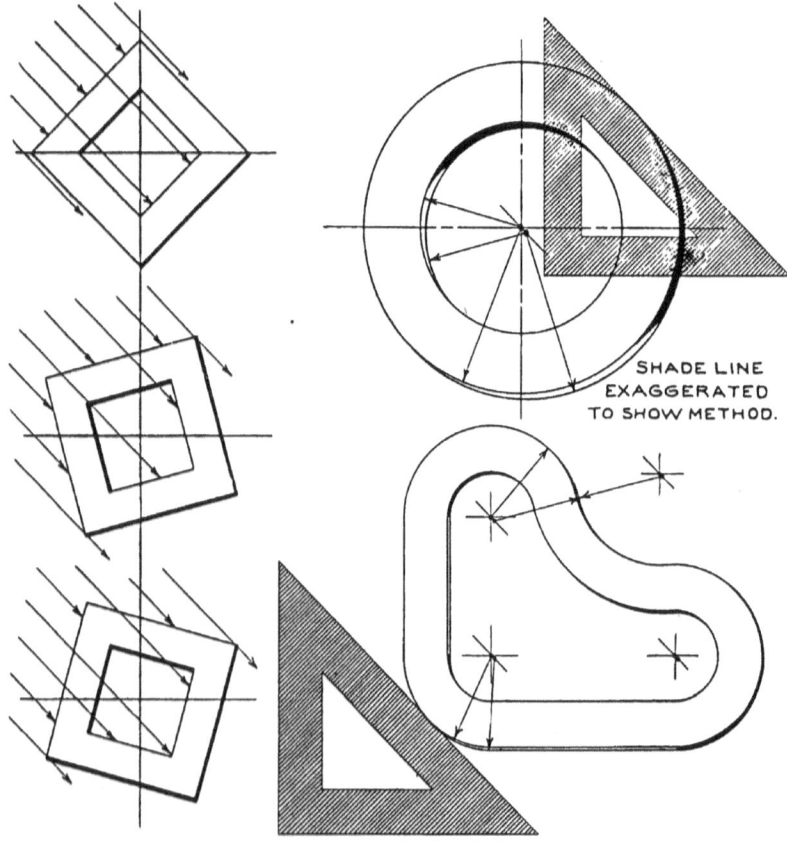

Fig. 14.

the paper as shown by the arrows to the left in Fig. 14. The division between light and dark surfaces is indicated by a heavy line about three times as thick as the outline. **No account is taken of the shadows cast by one portion of the object upon another.** In many cases the position of shade lines is entirely conventional, for example, in Fig. 13 the lower lines of the right-hand view, do not, strictly speaking, represent the divisions between a light and a

dark surface, yet it is the custom to shade them as shown. A system of placing the shade lines should be adopted and adhered to. **Place all shade lines outside the outlines of the figure. A line common to two surfaces is not shaded when both surfaces are visible.** Shade the views independently of each other. By placing a 45° triangle on the T square (see Fig. 14) and assuming the hypotenuse to be the ray of light it is easy to determine, by sliding the triangle along the T square, on just which surface the light does not impinge. See Fig. 11 for width of line.

2. To shade a circle or arc always move the needle point of the instrument, without changing the radius, down to the right at an angle of 45° and a distance equal to the desired thickness of the shade line. Do this by eye. (See Fig. 14.) This will make the shade line blend into the outline at the proper place, i. e., where the light ray is tangent to the curve. By placing the needle point in the original center and springing the pen slightly outward, the space between the original and eccentric curve can be filled in easily.

3. In cases where each end of a shaded arc joins a shade line the arc should be shaded by changing the radius and not moving the needle from the original center.

4. Pencil lines are not shaded.

INKING IN. 1. The majority of beginners make the mistake of drawing very fine lines; they look neat but are not practical. If the nibs of the pen are forced close together the ink will not flow readily and the result is a fine gray line. **A fairly heavy black line is correct,** see Fig. 11; this may be obtained by opening the nibs of the pen so that the ink flows readily.

2. The outside of the pen must be kept free of ink. Never allow ink to harden in a pen; wipe frequently, and when through using see that the pen is quite clean. Do not scrape with a knife.

3. When inking a drawing, first draw all circles and arcs, shading them as you go, after that draw the light straight lines, and finally the shaded straight lines. Dotted lines are not shaded. **Lines, letters and figures must be black.** If they have been lightened by erasure go over them until they are black.

4. If the surface of the paper has been roughened by erasures, so that ink will spread, it can be restored by rubbing with a soapstone pencil, ivory, bone, the finger nail, or a piece of hard surfaced paper.

5. Keep your paper and materials free from dust and particles of eraser to avoid blots and errors. Dust the drawing frequently.

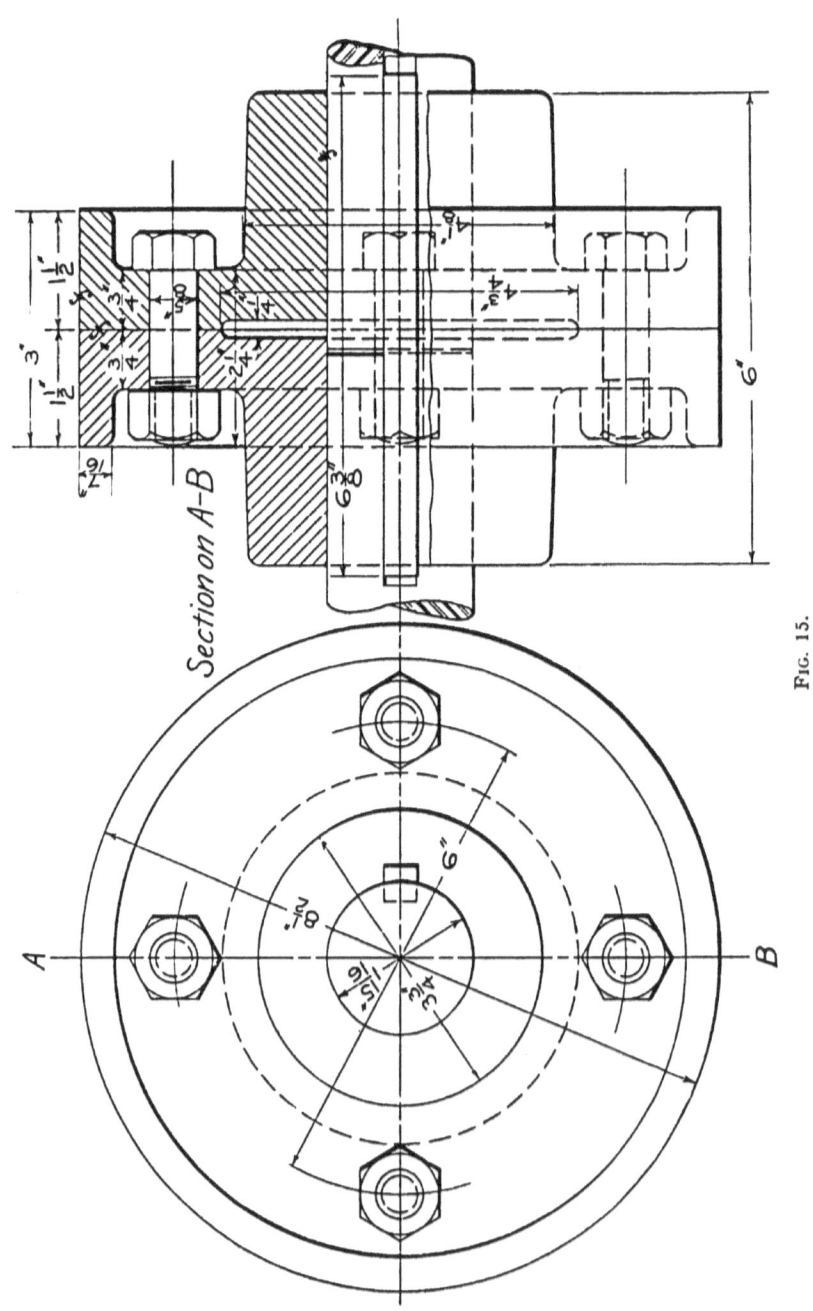

Fig. 15.

DIMENSIONING. 1. In dimensioning a drawing, full light lines are drawn to connect the points between which a dimension is to be given. The lines are terminated by arrow heads, and the dimension is written in a break, usually but not necessarily in the center of the line, provided for that purpose, as in Figs. 11 and 15. Dimensions should be kept in line. (See Fig. 16.)

2. **Arrow heads** are to be made with a fine writing pen. They should be small, neat and sharp, and touch the line to which they refer. (See Fig. 16.)

3. **Figures.**—All dimension figures on a drawing should be as near the same size as possible and not in proportion to the size of the dimension or drawing. Figures $\tfrac{3}{32}''$ high are large enough for all practical purposes. The figures in the numerator and denominator of a fraction should, for clearness, be as large as the whole numbers. (See Fig. 16.)

MAKE FIGURES THUS 1234567890 — $58\tfrac{1}{4}$ — $\tfrac{3}{32}''$
\vdash 3' \dashv $\tfrac{1}{4}''$ \vdash $2\tfrac{1}{2}''$ \dashv $\tfrac{3}{64}''$ \vdash $6\tfrac{9}{16}''$ Finished \rightarrow $\tfrac{7}{8}''$ \vdash $\tfrac{3}{32}''$

FIG. 16.

4. Figures when printed with lettering, as in a note or title, are made as high as the capitals.

5. **Figures must not be placed on top of lines, keep them in the open.**

6. When the space, in which a dimension is to be placed, is very small, the arrow heads may be reversed and placed with the dimension outside the space as shown in Fig. 17. When necessary from lack of room a dimension or note may be written in a convenient place and connected to the required point by a straight leader. Such a leader should always have an arrow head to indicate the point to which the dimension or note refers. (See Fig. 13.) When a dimension is placed on a section the cross-hatching is omitted at that point. (See Fig. 15.) Dimension a drawing before cross-hatching it.

FIG. 17.

7. **Fractions** must always have the dividing line made thus: $\tfrac{3}{8}''$, never $3/8''$, and the figures must not touch the line.

8. Extension lines are full fine lines used to prolong the lines of a drawing in order to place a dimension away from the picture or at a more readable place on the picture. They should not quite touch the drawing that they may not be mistaken for part of it. Fig. 15 illustrates the use of extension lines.

9. Dimensions may be given directly on the picture, but this frequently crowds the drawing too much. Dimensions should be placed outside the picture wherever clearness is gained thereby, using extension lines between which the dimensions are given. Dimensions must be kept in line as shown at the top of Fig. 13 and in Fig. 16.

10. Dimensions must always be placed at right angles to the dimension line, and for convenience should read only from the **bottom and right-hand side** of a drawing. (See Fig. 15.)

11. Dimensions of machine parts are usually given in inches, thus: $2\frac{1}{2}''$, $27''$, the inch mark being placed after the figure. In large work, such as roof trusses, dimensions over two feet are given in feet and inches, thus: $4'-0''$, $20'-8\frac{1}{2}''$, $3'-0\frac{7}{8}''$. The dash is essential to avoid errors.

12. All necessary dimensions must be placed on a drawing and care taken to avoid repetition. Give dimensions from finished surfaces wherever possible, from center lines, and from one center line to another, as in locating holes, etc. The size and location of holes must be given on the circular view. Center lines must never be used as dimension lines. Give dimensions to full lines, in preference to dotted ones, wherever practical. Over-all dimensions are useful in getting out material and should be given.

13. Useful dimensions are those which are of most service to the user of the drawing who should never be required to do any calculating. A little thought as to the process the material must undergo in the construction of the object, will quickly determine what dimensions to give.

14. Distribute the dimensions among all the views and do not crowd too many into one. Select the dimensions best suited to the views.

15. In giving the radius of an arc of a circle, the arrow head is placed only in the arc never at the center. The dimension line should be drawn radially but need not extend to the center. When a complete circle is on the drawing, always give the diameter, as in Fig. 13.

TABULATED DIMENSIONS. 1. Parts that are similar in shape but different in size should have their dimensions tabulated as shown in Plate J. A drawing of one of the parts being sufficient.

Abbreviations. The abbreviations and symbols most commonly used in practice are shown in Fig. 18.

ANGLE	∠	HEXAGONAL	Hex.
CENTER LINE	₵	INCHES	Ins. or "
CENTER TO CENTER	₵ to ₵	INSIDE	I.S.
CHAIN	━┅━┅━	LEFT HAND	L.H.
CIRCULAR PITCH	C.P.	OUTSIDE	O.S.
CIRCUMFERENCE	Circum.	PITCH CIRCLE DIAM.	P.C.D.
DEGREES	°	RADIUS	Rad. or R.
DIAMETRAL PITCH	D.P.	RIGHT HAND	R.H.
DIAMETER	Diam.	SQUARE	Sq.
FEET	Ft. or '	THREADS	Thds.
FINISH MARK	ƒ	THREADS PER INCH	Thds. per In.

FIG. 18.

Finish marks (Fig. 19) must be placed on all finished surfaces. They are made with a writing pen and should read from the bottom of the drawing only. (See Fig. 15.) Finish marks indicate that the surfaces marked must be machined, not necessarily polished, to the exact dimension given. The casting or forging is made full to allow for machining. When the whole piece is to be finished all over, omit these marks and print **"finished"** in the general title. (See Titles.)

FIG. 19.

SECTIONS. 1. As the object of a drawing is to represent the exact construction of the machine or part drawn, it is often convenient for clearness to represent some of the views or parts of them as sections through the object. Thus, in Fig. 15, the upper half of the right-hand view represents a section on a plane A–B normal to the plane of projection of the circular view. That is, we assume the near portion of the upper half of the object (as shown in the right-hand view only) to be cut away, back to the section plane and represent the object as it would then appear

2. Place a note directly under the view stating where the section is taken; thus, **Section on A—B, Section on X—Y –Z**. Use inclined lower case letters.

3. When the limit of a part in section is at a plane through the center line, the center line is made a full line as far as the section extends, and shaded if the conditions require it.

4. When the limit of a section is not at the center line, an irregular line (Fig. 11) is drawn to show a fractured surface. (See Fig. 15.) The latter method is frequently necessary to more clearly show the detail of the interior; for example the key and keyway in the illustration.

CROSS-HATCHING. 1. All portions of the material cut by a section plane are cross-hatched by lines making an angle of 45°, except where otherwise shown in the "Conventional Standard Cross-hatchings" Plate A. **Cross-hatching is done after a drawing is fully dimensioned, omitting it where the dimension is placed.** All sections of the same piece, in the same plane, are cross-hatched in the same direction. Cross-hatching never extends over a full line.

2. When two or more pieces, of the same or different material, show in a section adjacent to each other, the cross-hatching must be drawn in opposite directions. (See Figs. 15 and 30.)

3. Care should be taken to space the cross-hatching uniformly. This is readily done by eye, after a little practice on a separate sheet of paper. The appearance of a drawing, which is otherwise faultless, is often spoiled by poor cross-hatching.

4. Section lines should be somewhat finer than the outline and not too close. Use about a $\frac{1}{16}$" space.

Plate A shows the system of conventional cross-hatching to be used in this work. Note spacing and width of line.

5. When a section is taken longitudinally through a Shaft, Axle, Bolt, Spokes of Wheels, Ribs or Webs, these are not sectioned but are drawn full as though the cutting plane did not pass through them. (See Fig. 15.)

6. When the whole of a shaft, bar, channel or other long piece cannot be shown in its full length, it is represented broken as shown in Fig. 20, the break showing roughly the outline of the cross section of the piece.

CONVENTIONAL STANDARD CROSS-HATCHINGS

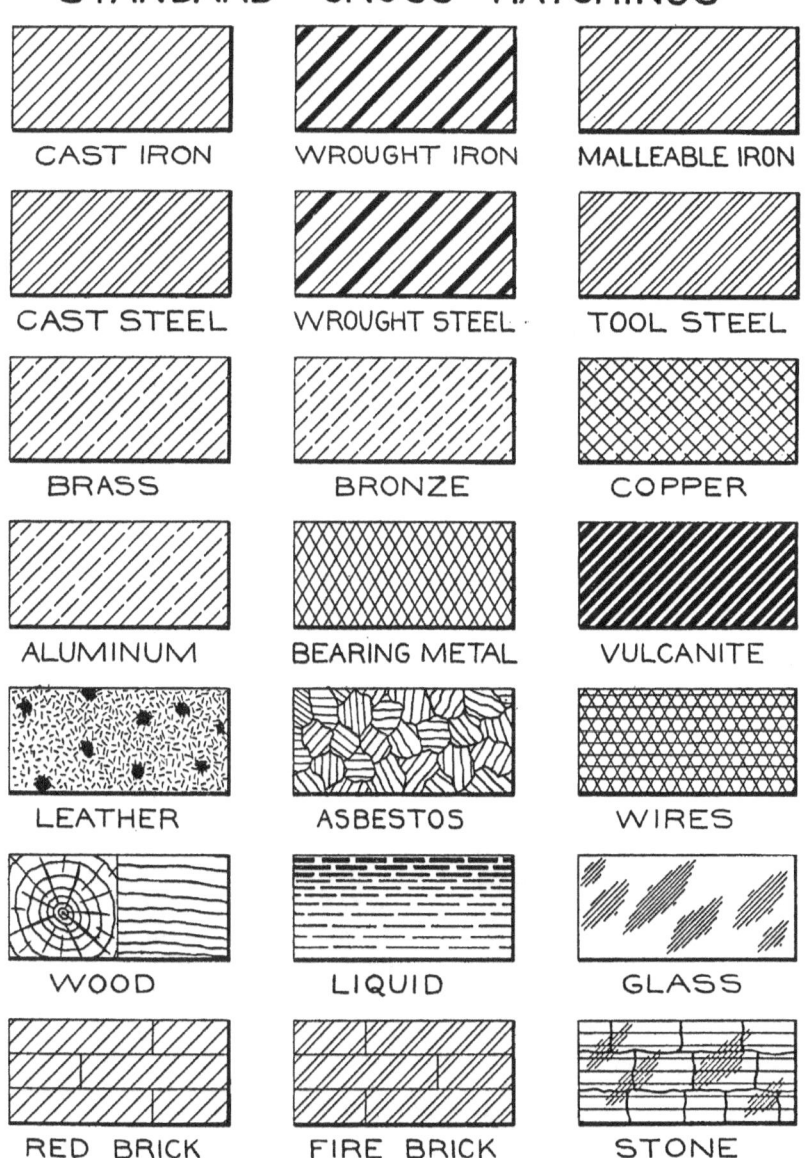

PLATE A.

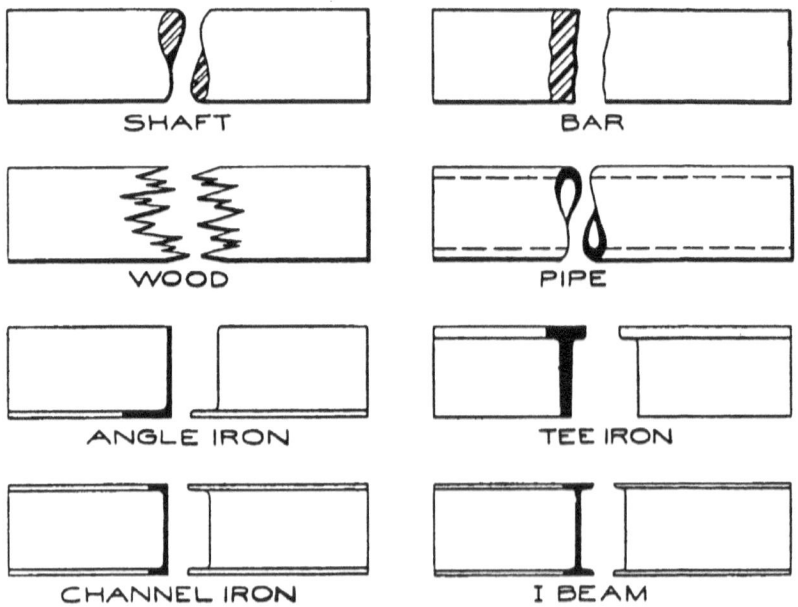

Fig. 20.

TINTING. 1. When a large part of a drawing is in section it is often more convenient to tint the drawing than to cross-hatch it. If this is done the drawing should be fully inked in with waterproof ink, omitting dimensions until the tint is applied.

2. The drawing should be freed from pencil marks and well cleaned before tinting, as the tint is readily removed with a pencil eraser. A cleaning rubber will tone it down if too dark.

3. It is well to go over the portions to be tinted with a brush, using clear water, just before applying the tint; this will prevent the tint from drying too rapidly. Make the tint light, then, by going over it again, if necessary, the proper shade may be obtained. Stir the tint in the saucer with every dipping of the brush. Remember that the process is that of tinting and not painting.

4. A smooth tint will result if it is done quickly, keeping a drop of tint on the paper just ahead of the brush and leaving the part tinted practically dry. An excess of moisture remaining will cause the tint to dry blotchy. If the tint runs over a line, brush back quickly with the finger.

5. In this tinting work use the moist water colors named for the materials in the list below.

The color mentioned first, for a given material, should predominate in mixing the tint representing that material. In any case a very small quantity of color will suffice.

Cast Iron..........Paynes Gray.
Wrought Iron......Prussian Blue.
Wrought Steel.....Prussian Blue and Crimson Lake.
Cast Steel.........Crimson Lake and Prussian Blue.
Brass..............Gamboge.
Bronze.............Gamboge and Crimson Lake.
Copper.............Crimson Lake and Gamboge.
Babbitt............Thin Ground India Ink.
Leather............Thin Ground India Ink and Burnt Sienna.
Wood...............Burnt Sienna.
Glass..............Prussian Blue and Gamboge.

6. Lines and dimensions may be placed directly on the tinted surface if necessary.

7. When the area to be tinted is large, the paper should be stretched before starting the drawing. This is done by thoroughly wetting the paper and pasting it, along the edges, to the drawing board.

LINE SHADING. **1.** Line shading is used to represent more clearly or more quickly the nature of the surfaces of which the piece is composed.

2. This method is often used where the number of views is limited or where it is desired to represent to those who are not familiar with the principles of mechanical drawing, the construction of a machine.

3. Book and magazine illustrations and Patent Office drawings are also examples.

4. The distribution of light and shade found in current practice in the case of a circular cylinder, can be produced by assuming the illumination to come from the opposite sources S and S_1 (Fig. 21) in parallel rays making 45° with the horizontal plane of projection and having their horizontal projections at 45° with the ground line.

LINE SHADING

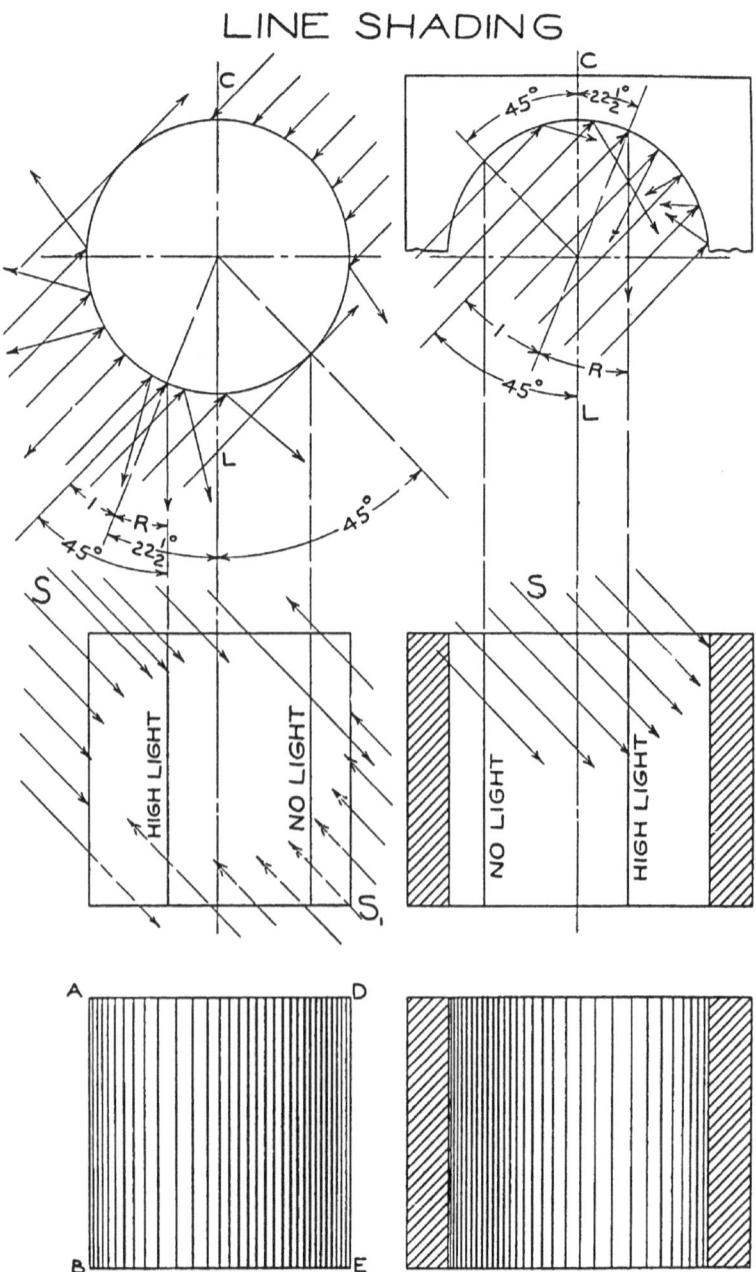

Fig. 21.

5. The brightest part of an illuminated object is that which reflects the rays of light directly into the eye of the observer. Assuming the light to fall as above described, and knowing the angle of reflection R must equal the angle of incidence I, reference to Fig. 21 will show that the high light must be $22\frac{1}{2}°$ around from the center line C L. At this point, and at this point only, a ray of light would be reflected normal to the plane of projection and to the eye of the observer.

6. By the same reasoning it will be seen that the dark element, or no light, is 45° around on the opposite side of the center line C L, for at this point the light rays are tangent and there is no reflected light.

7. Beyond this element the surface is slightly illuminated by the rays S_1 coming from below upwards as assumed.

8. The limiting elements A B and D E (Fig. 21) are of the same shade. The shades received by all surfaces of revolution are shown by lines which represent the generatrix in various positions, the intensity of the shade being effected by the thickness of the lines.

9. First, ink the outline of the drawing with a uniform line; omit dimensions, dotted lines, shade lines and center lines, although the latter are always pencilled for construction. Second, ink the shading, the straight lines first, and then the curved ones. Avoid making lines fine or too close together.

10. Practice line shading, suitable for the different surfaces on your drawing, on a separate sheet of paper and submit to your instructor for approval before you line shade your drawing.

11. Examples of line shading will be found on PLATES B, C, and D, which cover most shapes met with; study them and apply to your special case.

12. Each drawing must have a general title as shown on blueprint sketch from which the drawing is made.

13. If there are two or more pieces shown, place their respective names under them.

14. Do not use a knife on line shading; use a rubber to erase errors, then restore the surface of the paper by rubbing it with another piece of paper.

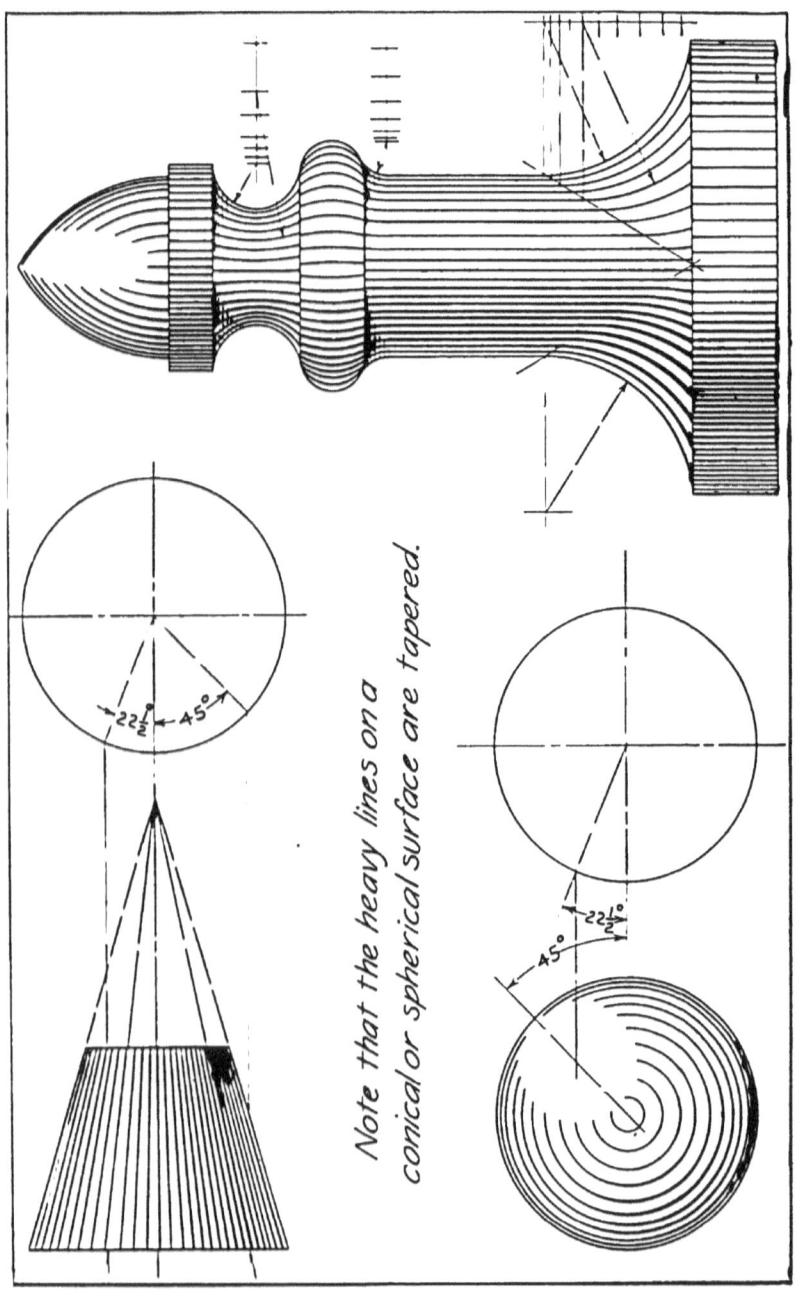

PLATE B.

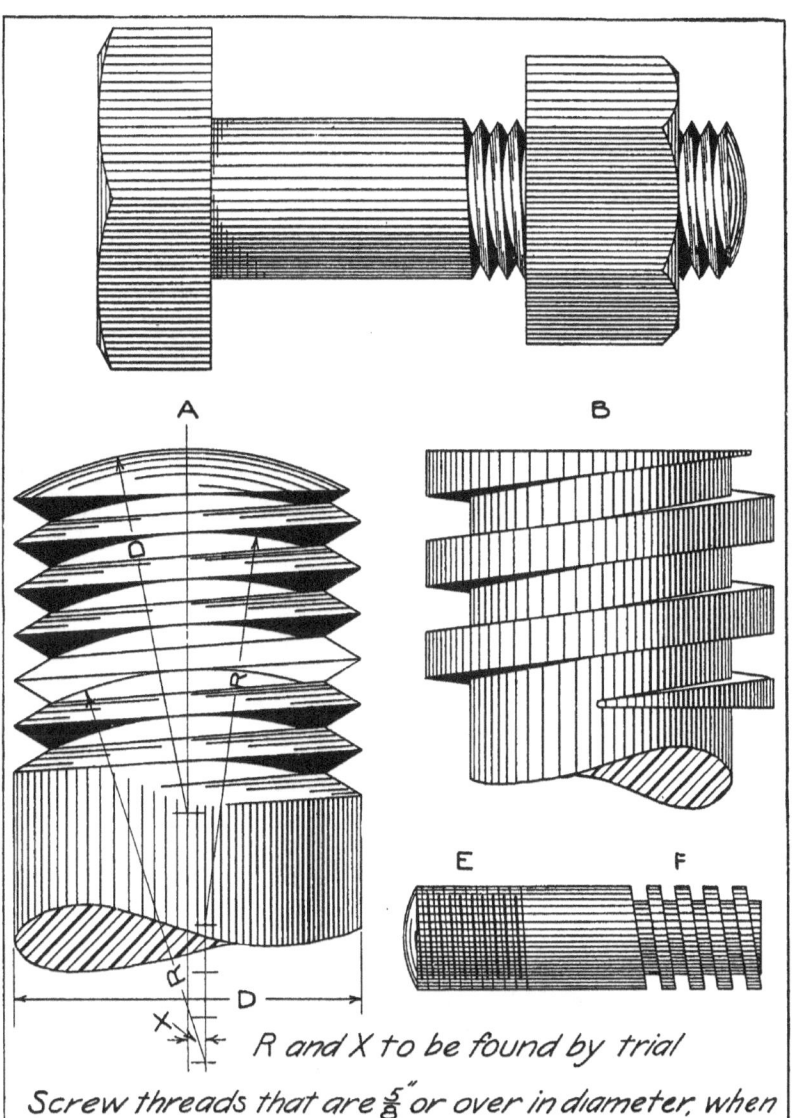

R and X to be found by trial

Screw threads that are $\frac{5}{8}''$ or over in diameter, when drawn to scale, should be drawn to the exact shape and pitch, the curve of the helix being neglected, and shade as shown at A and B. When under $\frac{5}{8}''$ Diam. use the conventional methods E and F

PLATE C.

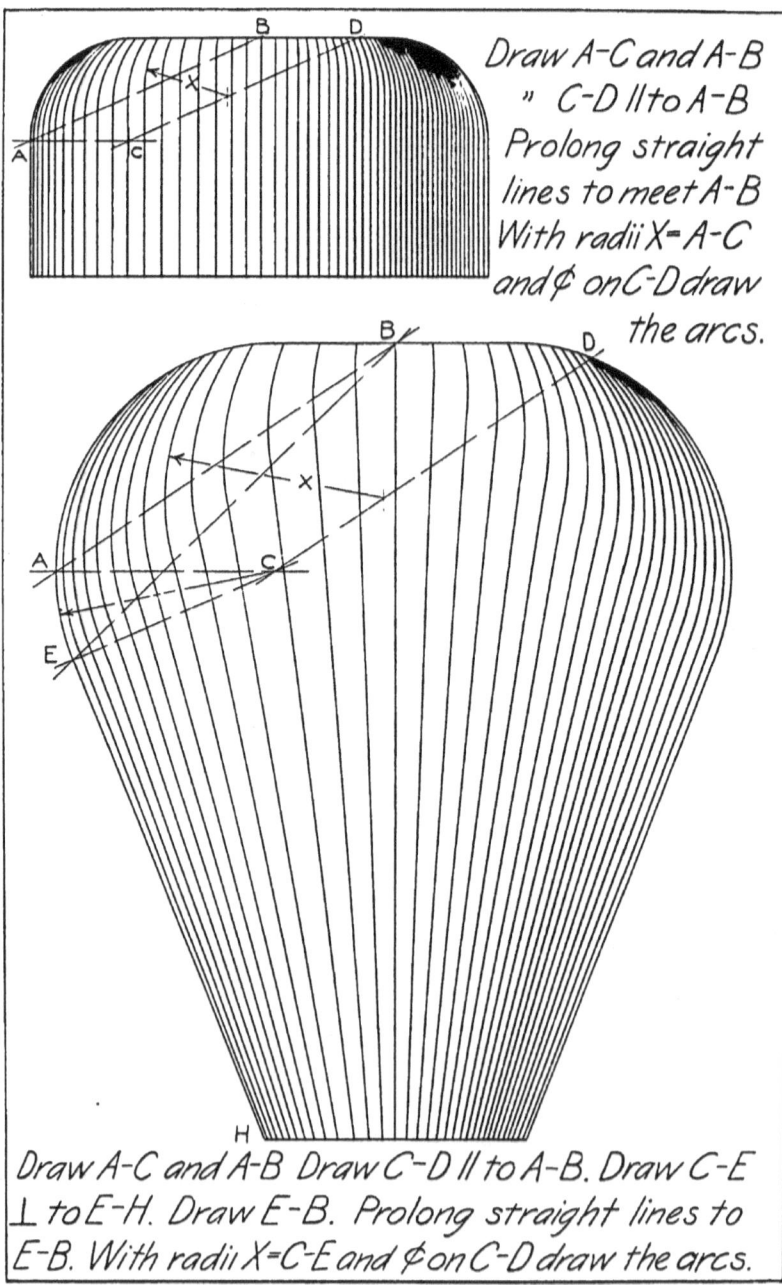

Draw A-C and A-B
" C-D ‖ to A-B
Prolong straight lines to meet A-B
With radii X=A-C and ¢ on C-D draw the arcs.

Draw A-C and A-B Draw C-D ‖ to A-B. Draw C-E ⊥ to E-H. Draw E-B. Prolong straight lines to E-B. With radii X=C-E and ¢ on C-D draw the arcs.

PLATE D.

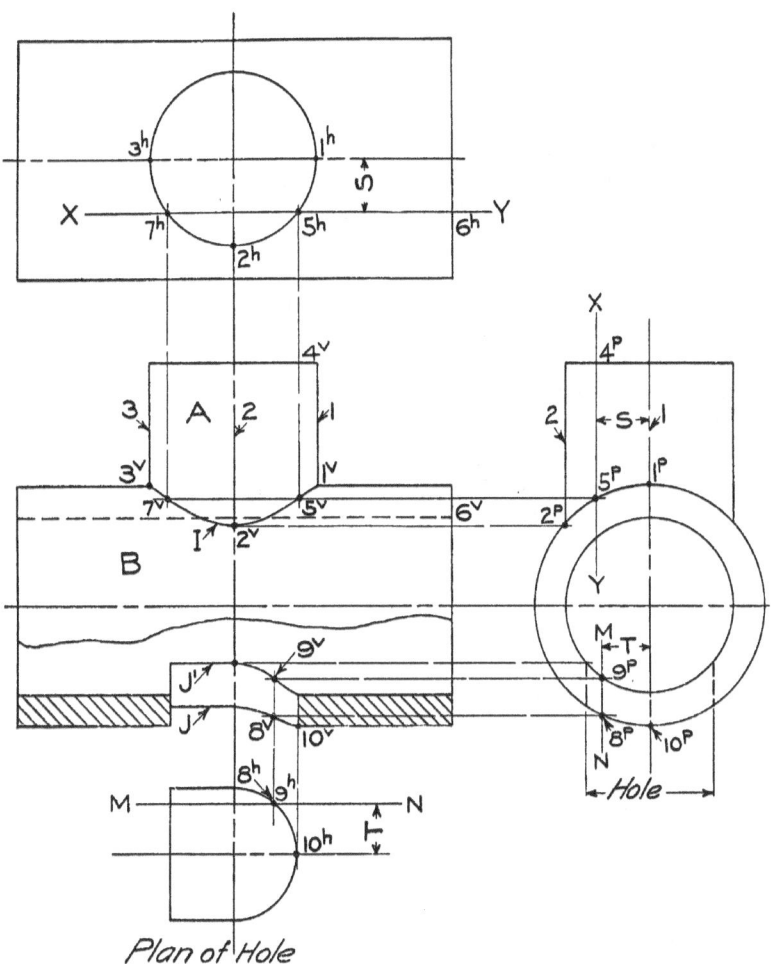

Fig. 22.

INTERSECTIONS. 1. The intersections of curved surfaces should be drawn as an aid to the understanding of a drawing.

2. Descriptive Geometry treats of the methods employed in finding intersections, but the student unfamiliar with this subject can plot most of the simpler ones met with in practice if he observes the following instructions.

3. Fig. 22 shows two intersecting cylinders A and B with axes at right angles and in the same plane. I is their line of intersection, its shape being determined by plotting points. These points are the intersections of elements in the cylindrical surface A with elements in the cylindrical surface B. Element 1 of A intersects element 1 of B at 1^v and element 3 of A intersects it at 3^v. Element 2 of A, see end view, intersects element 2 of B at 2^p, this point projected on the vertical plane is 2^v, and is the lowest point of the curve of intersection I. Intermediate points such as 5^v are found by passing planes in such a way that they cut elements from each cylinder, the intersection of the elements in any one plane being a point on the curve. For example, the plane X—Y at any distance S from the center line, see end view, cuts element 4^p5^p from A and 6^h5^h, see top view, from B. The points 5^p and 5^h projected on the vertical plane determine 5^v. This point being the intersection of two elements, is a point on the curve of intersection. Another point 7^v is determined by projection from 7^h.

4. A sufficient number of points should be plotted to determine the shape of the curve. Approximate the curve by drawing a light freehand line through the points plotted, as a guide for applying the Irregular (French) Curve. With the aid of the Irregular Curve a smooth curving line is drawn through the points.

5. Cylinder B is hollow and has been broken away to show a hole cut through its lower portion. This case is similar to the previous one, the difference being that the thickness of the cylinder is shown and the hole therefore intersects the inside as well as the outside surface of the cylinder B.

6. The plane M—N, see end view, contains elements of the cylindrical surfaces that pass through the points 8^p and 9^p as well as the element of 8^p9^p of the semi-cylindrical surface of the hole. These are the points in which the elements meet and if projected on the vertical plane, determine 8^v and 9^v which are points on the lines of intersections J and J^1.

7. Fig. 23 shows a pipe elbow with its center at O, intersected by an offset cylindrical outlet. In this case points in the line of intersection I are found by passing planes containing elements of the cylindrical surface and arcs on the surface of the elbow. Element 2 appears to intersect the elbow at b^p, end view, but a plane passed through 2 cuts from the elbow, front view, the arc $b^v2^vc^v$.

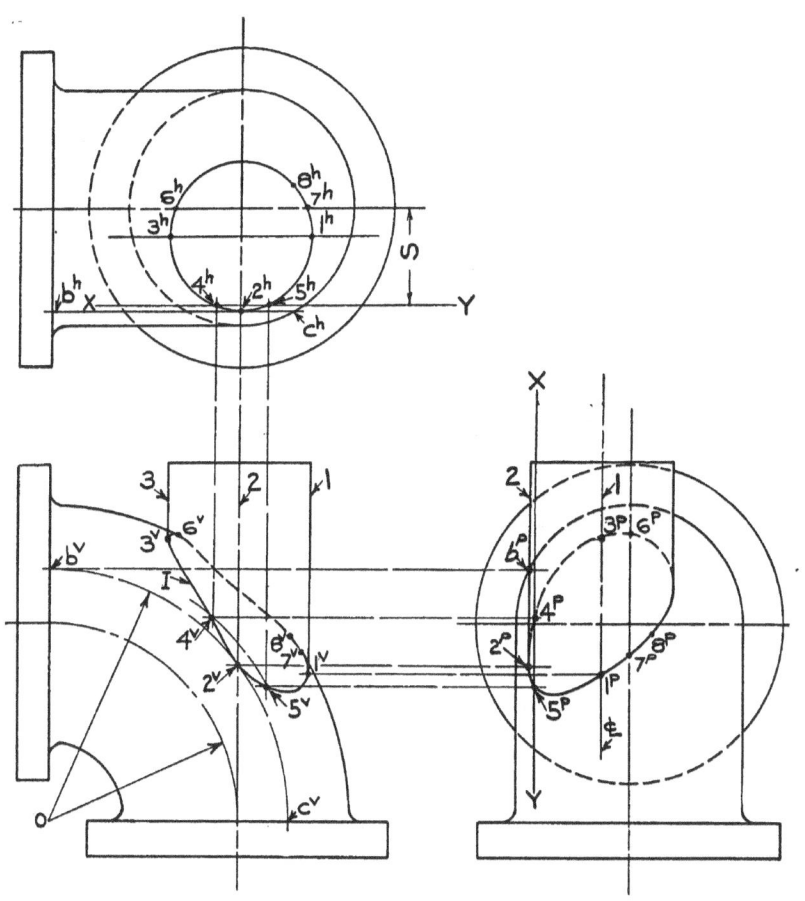

Fig. 23.

This arc is found by projecting the point b^p to the center line at b^v thus determining a point in the plane through which to draw an arc with O as its center. The element 2 lies in the plane of this arc and intersects it at 2^v which is a point on the line of intersection $1^v 2^v 3^v$. The point 2^v projected to the end view determines 2^p, a point on the intersection that appears in that view. Pass any other plane as X—Y at any distance S from the center line. The points of the lines of intersection that lie in this plane are 4^v and 5^v in the front view and 4^p and 5^p in the end view. A sufficient number of points are to be found through which curves of intersection may be drawn.

8. Note that between 6^v and 7^v, front view, the line of intersection replaces the portion of the arc of the elbow in this view.

Small slanting lower case Gothic letters, Reinhardt's System, to be used for descriptive matter. Notes to read from BOTTOM or RIGHT HAND SIDE of drawing, not diagonally. All lettering, on a drawing, should be made with a firm black line. Fine lines are to be avoided.

SMALL UPRIGHT CAPS TO BE USED FOR SUB-CAPTIONS, SUCH AS NAMES OF SEPARATE PIECES ON A DETAIL SHEET. ALSO USED FOR THE PART OF SECONDARY IMPORTANCE IN THE TITLE.

EXTENDED, COMPRESSED, OR SQUARE UPRIGHT CAPITAL LETTERS TO BE USED FOR THE PART OF FIRST IMPORTANCE IN THE TITLE. NO LARGER.

LETTERS OF THIS SIZE TO BE USED FOR SCALE, NAME, DATE, ETC.

PLATE E.

LETTERING. 1. Special attention should be given to lettering, as, when well executed, it adds greatly to the working value of a drawing. With care and constant practice any student can do satisfactory lettering.

2. The lettering on all drawings, unless otherwise directed, is to be done according to the system described in Reinhardt's "Free-hand Lettering," using inclined and upright letters of the "Gothic" type in the heights shown on Plate E.

3. The last half hour of each period in Course 492, first term, will be devoted to the practice of free-hand lettering.

4. For the small lettering in descriptive matter, notes, dimensions and arrow heads a "Gillott No. 390" pen should be used.

5. For the main title, large letters and when filling in a "Hewitt's Patent Ball Pointed Pen," No. 516F, is most suitable.

6. **Notes and descriptive matter should read from the Lower or Right-hand edge of a drawing and not in a diagonal direction.**

7. Index numbers on tracings are to be made as shown in Fig. 24.

8. Initials on the margin of drawings in Course 492, first term, are to be made with a ruling pen and exactly as shown in Fig. 25.

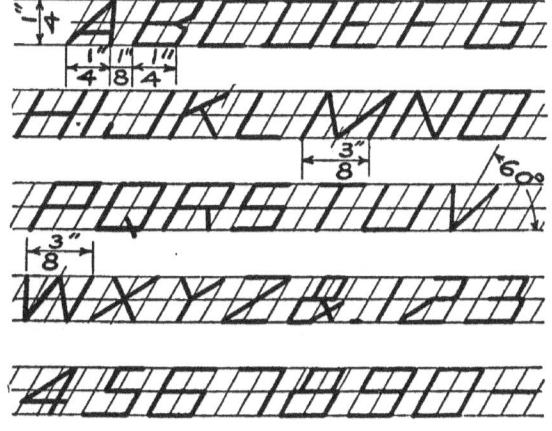

FIG. 25. FIG. 24.

TITLES. 1. Every drawing should have a general title (See Plate F) containing the following essentials:

NAME OF THE PIECE.
NAME OF THE MACHINE OF WHICH IT IS A PART.
QUANTITY REQUIRED, MATERIAL, FINISH.
SCALE, NAME OF DRAFTSMAN, DATE COMPLETED.

2. Strictly speaking, any one piece of a machine is a detail of that machine, but should not be designated as such in the title. Name it in the title when no other parts are drawn. When several pieces of a machine are drawn separately on a sheet, it then becomes a detail drawing and should have a general title as follows:

DETAILS OF
NAME OF THE MACHINE OF WHICH THEY ARE PARTS.
SCALES. NAME OF DRAFTSMAN. DATE COMPLETED.

3. **Sub-captions** (see Plate G) must be placed under each piece on a detail sheet, they should contain the following essentials:

NAME OF PIECE.
QUANTITY REQUIRED, MATERIAL, FINISH.
SCALE.

4. If the scale is the same for all the details it should be omitted from the sub-caption. Avoid using more than three scales on the one detail sheet.

5. **Part numbers** are frequently used as a substitute for names of pieces on a detail sheet. These numbers are necessary when the pieces are difficult to name concisely or are numerous and similar. "**Part number** ——" replaces "**name of piece**" in the sub-captions. On the assembly drawing the numbers must appear in circles with leaders to the parts designated.

6. **A bill of materials** should be placed on drawings that show several pieces assembled. Its form should be as shown on Plate G and should contain the following essentials.

BILL OF MATERIALS.
PRINCIPAL PIECE, QUANTITY REQUIRED, MATERIAL, FINISH.
SECONDARY PIECE, QUANTITY REQUIRED, MATERIAL, FINISH.
SMALLEST PIECE, QUANTITY REQUIRED, MATERIAL, FINISH.

The "**Quantity required**" in the **title** would be the number of units wanted. A unit being an assemblage of all the pieces specified in the **bill of material.**

The words "**as shown**" should be substituted for "**material**" and "**finish**" in the **title** when a **bill** is given.

7. **The Location of the Title on Drawings** in Courses 492 and 493 is shown in Fig. 6; Course 494, first term, in Fig 7, second term, on Plate K; Course 517 on Plate H.

Note the varying heights of each line of words according to their importance and the symmetrical appearance of the titles.

FORMS FOR TITLES

PISTON ROD
2 STEEL FINISHED
HALF SIZE A.S. KNOW. 2-18-1905

OUTBOARD BEARING
4"X 6" METROPOLITAN ENGINE
1 CAST IRON. FINISH AS INDICATED
SCALE 3"=1' M.Y. NAME 1-4-1905

ECCENTRIC AND STRAP
6"X 9" SLIDE VALVE BLOWER ENGINE
1 OF EACH AS SHOWN
ECCENTRIC CAST IRON FINISHED
STRAP PHOSPHOR BRONZE FINISHED AS SHOWN
SCALE 6"=1' W.H.O. DIDIT. 6-30-1905

DETAILS OF
10 TON JIB CRANE
SCALE 2"=1' NAME 5-17-1905

DETAILS OF
2" GOVERNOR
FOR AIR COMPRESSOR
FULL SIZE I. DREWIT. 10-31-1905

PLATE F.

FORMS FOR SUB-CAPTIONS

SUB-CAPTIONS TO BE PLACED CENTRALLY UNDER THE VIEWS OF EACH PART ON A SHEET OF DETAILS. OMIT SCALE IF ALL PARTS ON THE SHEET ARE TO THE SAME SCALE. THE SCALE OR SCALES MUST ALWAYS APPEAR IN THE MAIN TITLE.

PISTON RING
4-CAST IRON FINISHED
SCALE 3"=1'

JIB CHANNEL
2 CAMBRIA 15" - 25# CHANNELS
SCALE 2"=1'

FORM FOR BILL OF MATERIALS

The bill to be independent of the title. Place it in a conspicuous place on the drawing. Enter the items in the order of their importance.

BILL OF MATERIALS

Piston Body	1 Cast Iron	Finish as shown
Piston Follower	1 Cast Iron	Finished
Bull Ring	1 Cast Iron	Finished
Piston Ring	2 Cast Iron	Finished
Stud	4 Steel	
Nuts	4 Wrt. Iron	

5 TON BRIDGE CRANE
SPAN 35 FT. LIFT 18 FT. MANUAL POWER
FOR DETAILS SEE A-3452, A-3453
SCALE 2"=1 FT. A.B. DRAFTSMAN 5-19-1912

A-3451

DETAILS OF
5 TON BRIDGE CRANE
SPAN 35 FT. LIFT 18 FT. MANUAL POWER
FOR OTHER DETAILS SEE A-3453, ASSEMBLY A-3451
SCALES 4" AND 6"=1 FT. A.B. DRAFTSMAN 5-20-1912

A-3452

PLATE H.

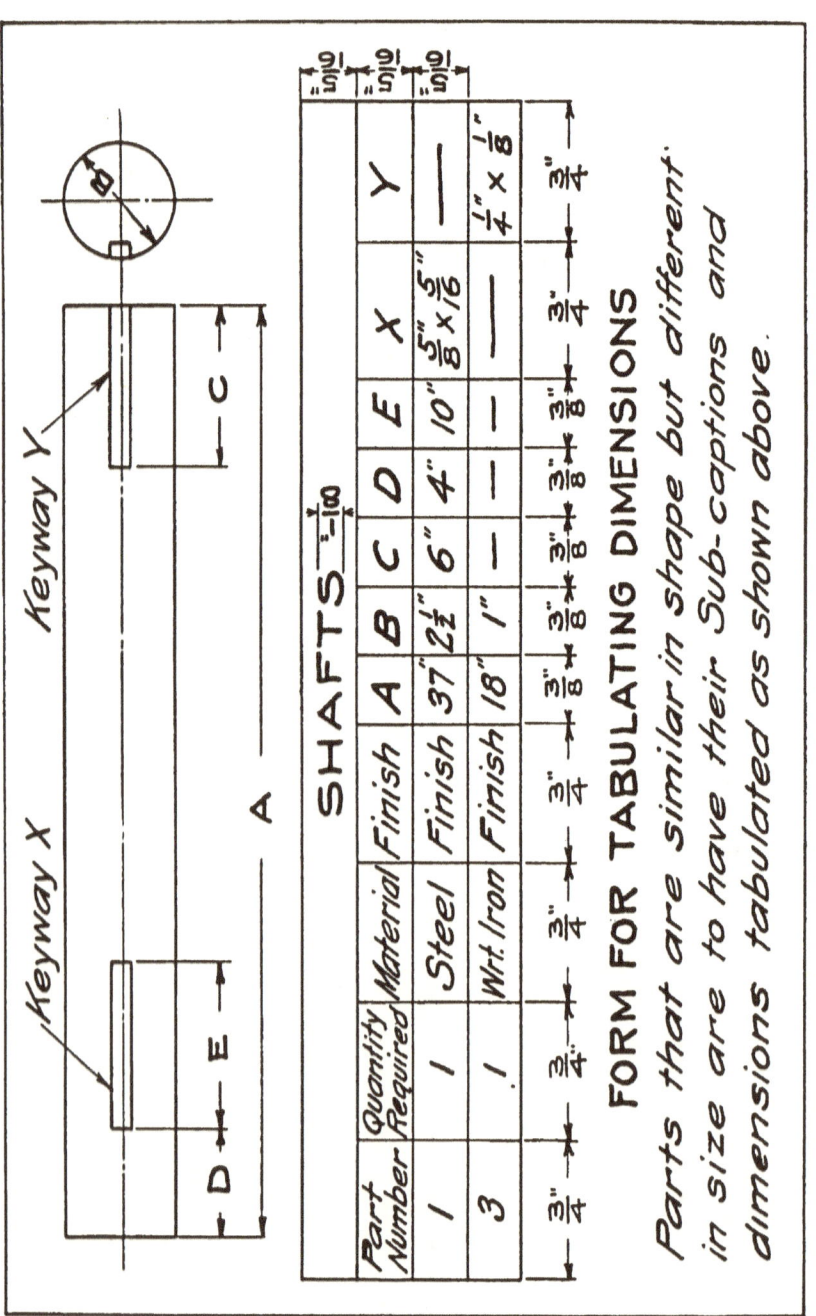

PLATE J.

ASSEMBLY DRAWINGS. 1. When a portion or the whole of a machine is drawn showing the various parts joined together in their relative positions, it is known as an assembly drawing.

2. The designer, in laying out a machine, must make the assembly drawing first, the details being drawn out to larger scales afterwards. On assembly drawings it is often well to show sections on different parallel planes in the same view.

ERECTING DRAWINGS. 1. Assembly drawings which show all the parts of the machine in place, but neglect the unnecessary and minute details of construction, are known as erecting drawings. These are frequently drawn to a scale smaller than that of the original design. They are sent with a machine to be used in setting it up at its destination.

2. Drawings of this class should be so dimensioned as to enable the erectors to distinguish and place the various parts in their proper relation to each other.

TRACING. 1. For reproducing drawings, without injury to the original, tracings are made upon tracing paper or cloth.

2. Tracing cloth or linen is used almost exclusively, owing to its wearing qualities. It is a specially prepared linen fabric, having one side glazed and the other rough, the former being known as the smooth side, the latter the dull side. Tracings can be made on either side of the cloth but the side used should be thoroughly rubbed with powdered chalk or soapstone to remove greasiness and permit the ink to "take" more readily, the excess chalk being thoroughly cleaned off before starting to trace. Tracings partly inked may be rubbed with powder, if the ink fails to take, without injury to the lines.

3. **The dull side of the cloth is to be used for all tracings** unless otherwise directed. It is easier to draw pencil lines on the dull side when making additions to views or checker's corrections. Drawings made on the dull side will make the tracing lie flat after removing from the board and not roll up, an objectionable feature caused by drawing on the smooth side.

4. Fine thin lines are to be avoided when making a tracing, as the light, in printing, will burn through such lines, causing the blue-print to appear blurred and indistinct. Read "Inking In" paragraph 3.

5. Erasures may be made as on paper, the pencil eraser usually being sufficient. The ink eraser should be used with care to avoid cutting the fabric. Place a triangle or other hard surfaced article under the cloth when erasing. Wherever an erasure has been made,

the place should be rubbed with a soapstone pencil or powdered chalk before re-inking to prevent the ink from passing through the cloth.

6. Ink dropped upon tracing cloth should never be blotted, but should be smeared as quickly as possible with the thumb, using a scooping up motion. When the smear has dried it is readily erased with the pencil eraser.

7. Pencil marks can be removed with the Art Gum cleaning rubber without affecting the ink lines. Before trimming tracings read the paragraph on Trimming.

BLUE-PRINTS. 1. Original drawings are seldom sent into the shop. Duplicates in the shape of either blue-prints (white lines on a blue ground) or white prints (blue or black lines on a white ground) are used in place of them.

2. These prints are moderate in cost and can be produced in endless numbers. They are obtained by exposing a sensitized paper or cloth to light rays. A positive tracing of the original drawing on a translucent medium such as tracing cloth or paper, is interposed between the light and the sensitized paper and in direct contact with the latter, the time of exposure depending upon the intensity of the light and the composition of the sensitizing emulsion.

3. The age, or length of time since the paper has been sensitized modifies the time of exposure. The fresher the paper the less exposure required. The prints are fixed by immersing for about ten minutes in clear water. Special papers require the addition of chemicals to the fixing bath. Instructions for the treatment of such papers generally accompany them.

SKETCHING. 1. The student will be required to provide himself with the following sketching outfit before he will be allowed to proceed with Course 493, second term.

1 Department standard fibre sketch board and steel clip.
1 Package Department standard cross-section paper $\frac{1}{10}''$ ruling.
1 – 3H lead pencil.
1 Green pencil eraser.
1 – 2 Ft. rule.
1 Pair 6'' firm joint inside calipers, good grade.

2. The tools enumerated above are the only ones to be used by the student for making sketches.

3. The object of a sketch is to give, in as few views as possible, sufficient information as to the shape and size of the machine

FIG. 26.

or the part represented to enable a draftsman to make complete working drawings. Sketches are to be made freehand on cross-section paper, ruled 10 divisions to the inch.

4. Each sketch sheet must contain the name of the machine at the top and directly under the views the name of the piece, quantity required, material and finish, and the part number in a circle. See

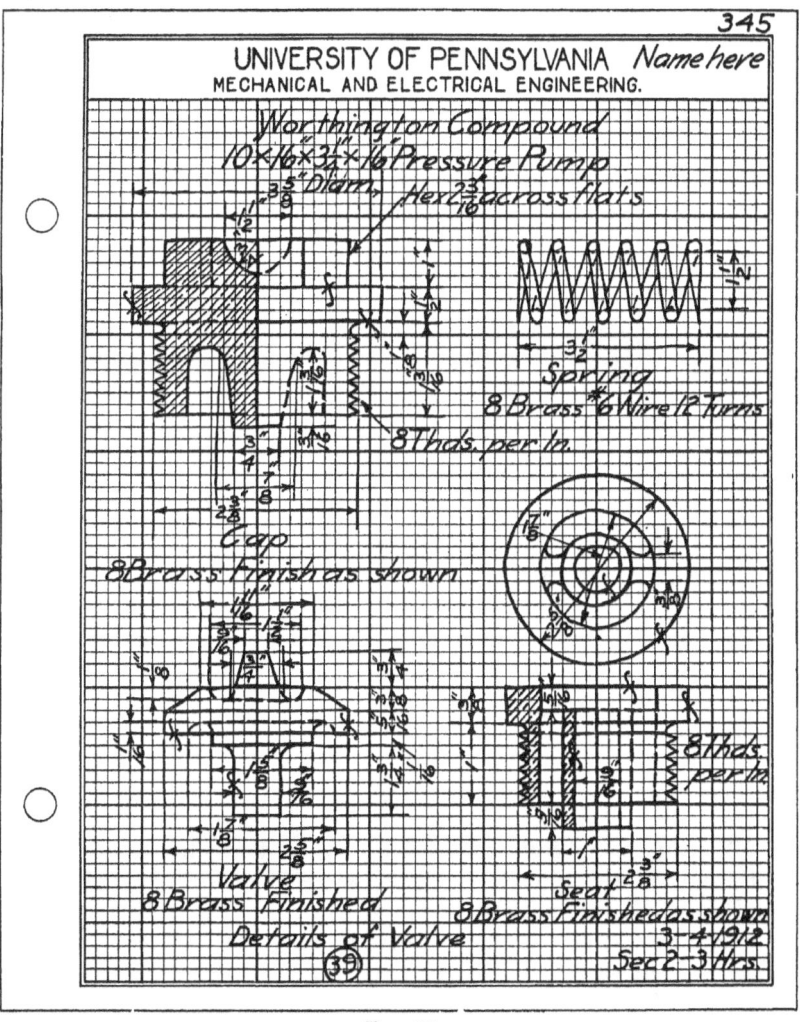

Fig. 27.

Fig. 26. The student's name, date completed and total time consumed in sketching all views of each piece are to be placed as shown on Figs. 26 and 27.

5. The size of the sketch should not be in proportion to the size of the object, but should be large enough to contain all dimensions without being crowded. When the piece is large or complicated, the various views should be placed on separate sheets.

6. If more than one sheet is required, to properly portray the piece, page the sheets in the lower left corner as shown in Fig. 26.

7. The piece should first be sketched by eye, endeavoring to maintain its relative proportions before taking any measurements.

8. The dimension lines with arrow heads are then placed where the dimension figures will show to the best advantage. Finally the piece is measured and the dimensions placed in the spaces previously provided.

9. In general, the same views, sections, etc., which would be used in making working drawings are used in sketching, except that in the latter many abbreviations are used. For example, in Fig. 27 only one view of each detail is shown, the plan being omitted, and the abbreviations **Diam.** and **Hex.** indicate that those portions are round and hexagonal. In the same way **Sq.** for square, **Oct.** for octagonal, and other abbreviations are used. (See **Abbreviations**, Fig. 18.)

10. When a piece is symmetrical about an axis, a view of one-half of the object is often sufficient. (See Fig. 26.) By taking advantage of these and similar points, both time and labor are saved.

11. The pieces are to be sketched separately and measurements taken independently, except in the case of large pieces when one student may assist another where needed.

12. Directions given for dimensioning drawings are applicable to sketches, although it is better to give too many dimensions, than too few, as the student will not have excess to the machine when he makes the working drawings from his sketches.

13. Rough castings should be measured to the nearest sixteenth and allowance made for draft, when this affects the required measurement. On finished work, measure as closely as possible. Judgment should be exercised when making measurements, especially of rough work, as an apparently odd dimension may be due to the irregularities of casting or forging.

14. Dimensions should be referred to center lines and to finished surfaces rather than to rough ones.

15. The radii of all curves should be given. To ascertain these, take a piece of paper and with a pencil mark the outline of the curve upon it, and then with a pair of calipers, used as dividers,

obtain the correct radius. When this cannot be done, take a wire or thin strip of lead and bend it around the curve, and with the aid of this mark the outline on paper and proceed as before.

16. Holes should always be located by their centers. Where there are several holes of the same size, similarly located in a piece, it is not necessary to give the diameter of more than one of them.

17. Tapering and tapped holes should always be noted. The number of threads will be understood to be standard unless otherwise noted.

18. When measuring the depth of holes, give the distance to the point where they begin to taper. (See dimension H on Fig. 31.)

19. The dimension of a cavity, from which the open calipers can not be extracted, may be obtained by scratching a cross on each leg of the caliper and measuring the distance between their centers; extract the calipers and adjust the crosses to the distance read, the measurement across the caliper points is the one desired.

20. All sketches will be checked with red ink and returned for correction. The corrections must be made and the sketch returned on or before the date stamped on the back.

GEARS. 1. On Plates L and M will be found the conventional lines and notations for spur and bevel gears.

2. For the theory of gearing and method of drawing various types of gear wheels, the student, when the occasion arises, is referred to one of the many books on the subject.

George B. Grant's "Treatise on Gears," and Brown & Sharpe's "Practical Treatise on Gearing" and "Formulæ in Gearing," are published by the manufacturers.

DRAWING THE STANDARD INVOLUTE TOOTH
USING GRANT'S INVOLUTE ODONTOGRAPH
STANDARD INTERCHANGEABLE TOOTH, CENTERS ON BASE LINE

NUMBER OF TEETH	DIVIDE THE NUMBER BY DIAMETRAL PITCH FOR		MULTIPLY NUMBER BY CIRCULAR PITCH FOR	
	FACE RADIUS	FLANK RADIUS	FACE RADIUS	FLANK RADIUS
10	2.28	.69	.73	.22
11	2.40	.83	.76	.27
12	2.51	.96	.80	.31
13	2.62	1.09	.83	.34
14	2.72	1.22	.87	.39
15	2.82	1.34	.90	.43
16	2.92	1.46	.93	.47
17	3.02	1.58	.96	.50
18	3.12	1.69	.99	.54
19	3.22	1.79	1.03	.57
20	3.32	1.89	1.06	.60
21	3.41	1.98	1.09	.63
22	3.49	2.06	1.11	.66
23	3.57	2.15	1.13	.69
24	3.64	2.24	1.16	.71
25	3.71	2.33	1.18	.74
26	3.78	2.42	1.20	.77
27	3.85	2.50	1.23	.80
28	3.92	2.59	1.25	.82
29	3.99	2.67	1.27	.85
30	4.06	2.76	1.29	.88
31	4.13	2.85	1.31	.91
32	4.20	2.93	1.34	.93
33	4.27	3.01	1.36	.96
34	4.33	3.09	1.38	.99
35	4.39	3.16	1.39	1.01
36	4.45	3.23	1.41	1.03
37–40	4.20		1.34	
41–45	4.63		1.48	
46–51	5.06		1.61	
52–60	5.74		1.83	
61–70	6.52		2.07	
71–90	7.72		2.46	
91–120	9.78		3.11	
121–180	13.38		4.26	
181–360	21.62		6.88	

DRAW THE PITCH LINE, SPACE OFF THE PITCH POINTS 1-2-3 ETC. BY DIVIDING THE CIRCLE INTO 2× NO OF TEETH SPACES OR ½ CIRCULAR PITCH DISTANCES.
DRAW ADDENDUM LINE OUTSIDE PITCH LINE A DISTANCE = 1 ÷ DIAMETRAL PITCH OR ⅓ CIR. PITCH. DRAW DEDENDUM LINE THE SAME DISTANCE INSIDE OF PITCH LINE AND CLEARANCE LINE INSIDE DEDENDUM LINE ⅒ THIS DISTANCE.
DRAW BASE LINE INSIDE OF PITCH LINE A DISTANC = 1/60 PITCH DIAMETER.
WITH RAD. F AND CEN. ON BASE LINE DRAW FACE FROM PITCH TO ADDENDUM.
WITH RAD. R AND CEN. ON BASE LINE DRAW FLANK FROM PITCH TO BASE LINE.
DRAW RADIAL LINES FROM BASE TO DEDENDUM AND ROUND OFF INTO CLEARANCE.
RACK:— DRAW STRAIGHT LINES THROUGH PITCH POINTS 15° WITH NORMAL, ROUND INTO CLEARANCE. P = 2.1 ÷ DIAM.PITCH OR .67× CIR. PITCH, ℄ ON PITCH LINE.

PLATE L.

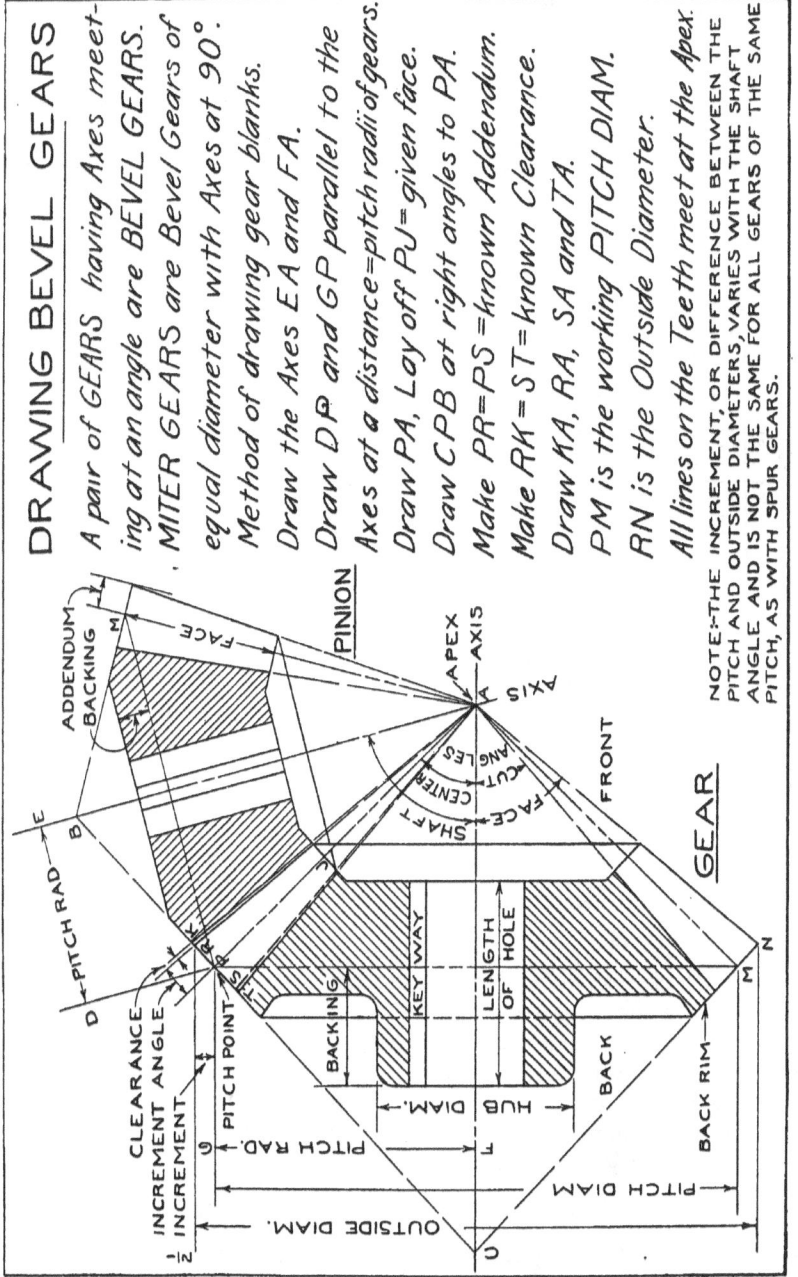

DRAWING BEVEL GEARS

A pair of GEARS having Axes meeting at an angle are BEVEL GEARS. MITER GEARS are Bevel Gears of equal diameter with Axes at 90°. Method of drawing gear blanks.

Draw the Axes EA and FA.
Draw DP and GP parallel to the Axes at a distance = pitch radii of gears.
Draw PA, Lay off PJ = given face.
Draw CPB at right angles to PA.
Make PR = PS = known Addendum.
Make RK = ST = known Clearance.
Draw KA, RA, SA and TA.
PM is the working PITCH DIAM.
RN is the Outside Diameter.
All lines on the Teeth meet at the Apex.

NOTE:— THE INCREMENT, OR DIFFERENCE BETWEEN THE PITCH AND OUTSIDE DIAMETERS, VARIES WITH THE SHAFT ANGLE AND IS NOT THE SAME FOR ALL GEARS OF THE SAME PITCH, AS WITH SPUR GEARS.

PLATE M.

SCREW THREADS.

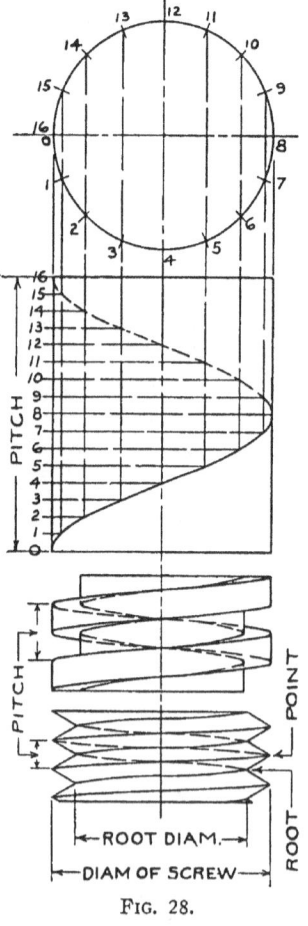

Fig. 28.

1. If a point moves on the surface of a circular cylinder, so that its motion around the axis and parallel to the axis is uniform, the path of the point is a **helix or screw curve.**

2. The method of drawing the helix is shown in Fig. 28, the true shape of a V and a square thread being shown. When drawing screw threads, except for very large diameters, it is not necessary to lay down the curve of the helices of which they are comprised. Straight lines properly drawn from point to point and root to root answer all practical purposes. (See Fig. 29.) The standard thread shapes are shown in Plates N and O.

3. **To draw a screw thread** lay off the pitch of the points accurately on one side. Draw shape of threads on that side. Locate any one point on opposite side. Draw the point line across, then draw all point lines parallel to this one. Draw shape of threads on opposite side. Draw root lines across.

4. **A right-hand thread** is one that will cause a threaded piece to advance into a tapped hole when the piece is turned clockwise. (See Fig. 29.)

5. **A left-hand thread** will cause the piece to advance when turned counter-clockwise. In both cases the threaded piece must be between the manipulator and the tapped hole.

6. If a threaded piece is held horizontally with the axis at right angles to the body, the threads seen will incline away from the body from left to right for a right-hand thread and from right to left for a left-hand thread. Threads are understood to be U. S. standard and right-hand unless otherwise specified.

7. The pitch of a single thread is the distance between two adjacent points. Or, in other words, the pitch is the distance the point would advance parallel to the axis in one revolution, e. g., single thread $\frac{1}{4}''$ pitch, 4 pitch, or 4 threads per inch. (Fig. 28.)

8. On double, triple or other multiple threads the lead is the distance from one point to the next point of the same thread

RIGHT HAND INSIDE AND OUTSIDE SCREW THREADS

SINGLE V. DOUBLE V. SINGLE SQ. DOUBLE SQ.

SINGLE V. DOUBLE V. SINGLE SQ. DOUBLE SQ.

LEFT HAND INSIDE AND OUTSIDE SCREW THREADS

FIG. 29.

measured parallel to the axis. The distance between two adjacent threads is sometimes called the divided pitch. The lead is the one generally specified for the machine shop (see Fig. 29); e. g., double thread $\frac{1}{2}''$ lead or 2 pitch; triple thread $\frac{3}{4}''$ lead or $1\frac{1}{3}$ pitch. Triple thread 3 pitch, means three threads each making three revolutions per inch.

9. The diameter of a thread is the extreme outside diameter of the threaded portion of a piece (See Fig. 30 for sections through threads.)

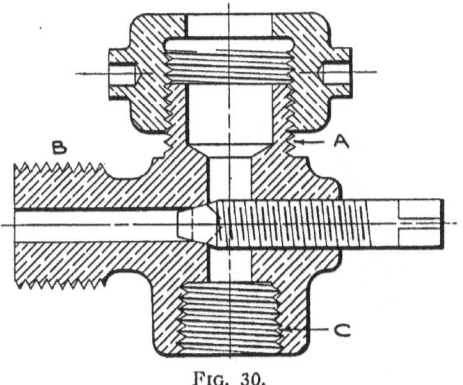

FIG. 30.

TAPPED HOLES. 1. The diameter of a tapped hole is the outside diameter of the threaded piece that would fit that hole, not the apparent diameter of the hole. (See Fig. 31.)

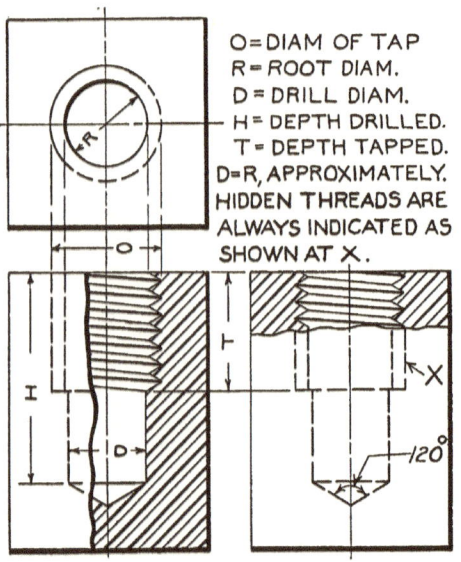

O = DIAM OF TAP
R = ROOT DIAM.
D = DRILL DIAM.
H = DEPTH DRILLED.
T = DEPTH TAPPED.
D = R, APPROXIMATELY.
HIDDEN THREADS ARE ALWAYS INDICATED AS SHOWN AT X.

FIG. 31.

2. **Drill size for tap** is the diameter of the hole which is drilled to prepare it for the tap, and which leaves the proper amount of stock for threads. Drills have a conical point which is 118° or, for all practical purposes on a drawing, 120°. Fig. 31 shows the shape of the bottom of a hole which has been drilled. The hole in this case has not been tapped to its full depth.

3. When a section is taken through a tapped hole, the inclination of the screw thread at the back of the hole is reversed. A little thought with reference to Figs. 29, 30, 31 and 32 will make this clear.

4. **Hidden threads** are always represented by parallel dotted lines. (See nuts, Fig. 15, hole, Fig. 31, and bolt in Fig. 32.)

CONVENTIONAL THREADS. 1. This method of showing screw threads is to be used, for clearness and economy, when the diameter of a thread, as drawn to scale, is less than $\frac{5}{8}''$. (See Fig. 32.)

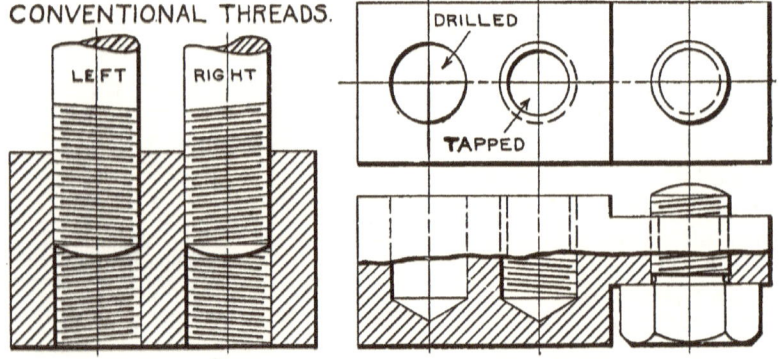

FIG. 32.

2. Conventional threads, as shown in Fig. 32, are used for threads of all standards. It is not necessary that the number of divisions should correspond with the actual number of threads. If the thread is other than the U. S. Standard, or if the number of threads does not correspond with the standard number for that diameter, there should be a note to that effect, thus "13thds per inch," "Square Threads 4 per inch," "Double Square Thread 2 pitch," "Triple V Thread $\frac{1}{2}''$ Lead," "$\frac{3}{4}''$ Pipe Thread," "Taper Thread 14 per inch, taper x in. per ft."

3. The spacing of the lines should be done by eye; pencil lines may be drawn to limit the length of the heavy root lines. The inclination of the lines should be practically the same as though the thread were drawn out to its actual shape. That is, for a single thread a point on one side should be diametrically opposite the adjoining root. For a double thread the point on one side should be diametrically opposite the point of the next thread. For triple threads the point on one side is diametrically opposite the next root but one. Fig. 29 will make this clear.

4. Conventional threads are not to be used whenever a section is taken through two pieces which are screwed together (see A, Fig. 30), both of which show in section, or when a thread is isolated (see B, Fig. 30), but cut by the section plane.

5. Tapped holes are shown as in Fig. 32 by two circles, the inner one full and the outer one half full and half dotted. All threaded holes should have a note designating the size they are to be tapped. $\frac{3}{4}''$ Tap means that the hole is to be tapped to take a screw $\frac{3}{4}''$ in diameter.

SCREW THREAD PROPORTIONS AND TABLES. The standard forms and proportions of screw threads in practical use in the United States will be found on Plates N and O.

BOLTS. 1. The standard proportions for bolt heads and nuts shown on Plate M were adopted by the Franklin Institute, December, 1864.

2. Manufacturers have deviated slightly from these proportions, owing to the materials used in their manufacture not being commercial sizes.

3. When drawing bolts and nuts, take dimensions from table on Plate Q and use the method shown on Plate P for approximating the curves which are, in reality, portions of hyperbolas, the results of chamfering.

MACHINE SCREWS. 1. Standard machine screws are shown on Plate R. The values in the table are very close to the A. S. M. E. Standard.

U.S. STANDARD SCREW THREAD
SELLERS OR FRANKLIN INSTITUTE STANDARD

p = PITCH OF THREAD = 1 ÷ NO. OF THDS. PER IN.
δ = DEPTH OF THREAD = $p \cos 30°$
POINT IS CUT OFF $\frac{1}{8}\delta$, ROOT IS FILLED IN $\frac{1}{8}\delta$
$h = \frac{3}{4}\delta = \frac{3}{4} p \cos 30° = .65p$
D = OUTSIDE DIAM. d = EFFECTIVE DIAM. AT ROOT
$d = D - 2h = D - 2 \times .65p = D - 1.3p$

TAP DIAM	DRILL HOLE FOR TAP	NO OF THDS	TAP DIAM	DRILL HOLE FOR TAP	NO OF THDS
$\frac{1}{4}$	$\frac{3}{16}$	20	2	$1\frac{23}{32}$	$4\frac{1}{2}$
$\frac{5}{16}$	$\frac{1}{4}$	18	$2\frac{1}{4}$	$1\frac{31}{32}$	$4\frac{1}{2}$
$\frac{3}{8}$	$\frac{19}{64}$	16	$2\frac{1}{2}$	$2\frac{3}{16}$	4
$\frac{7}{16}$	$\frac{11}{32}$	14	$2\frac{3}{4}$	$2\frac{7}{16}$	4
$\frac{1}{2}$	$\frac{27}{64}$	13	3	$2\frac{41}{64}$	$3\frac{1}{2}$
$\frac{9}{16}$	$\frac{15}{32}$	12	$3\frac{1}{4}$	$2\frac{15}{16}$	$3\frac{1}{2}$
$\frac{5}{8}$	$\frac{33}{64}$	11	$3\frac{1}{2}$	$3\frac{3}{32}$	$3\frac{1}{4}$
$\frac{11}{16}$	$\frac{37}{64}$	11	$3\frac{3}{4}$	$3\frac{5}{16}$	3
$\frac{3}{4}$	$\frac{1}{5}$	10	4	$3\frac{9}{16}$	3

V-STANDARD SCREW THREAD
TABLE GIVES ACCEPTED PITCH FOR SAME

p = PITCH OF THREAD = 1 ÷ NO. OF THDS. PER INCH
h = DEPTH OF THREAD = $p \cos 30° = .866p$
D = OUTSIDE DIAM. d = EFFECTIVE DIAM. AT ROOT
$d = D - 2h = D - 2 \times .866p = D - 1.732p$

TAP DIAM	DRILL HOLE FOR TAP	NO OF THDS	TAP DIAM	DRILL HOLE FOR TAP	NO OF THDS			
$\frac{1}{4}$	$\frac{3}{16}$	20	$\frac{7}{8}$	$\frac{47}{64}$	9	2	$1\frac{11}{16}$	$4\frac{1}{2}$
$\frac{5}{16}$	$\frac{15}{64}$	18	1	$\frac{13}{16}$	8	$2\frac{1}{4}$	$1\frac{7}{8}$	$4\frac{1}{2}$
$\frac{3}{8}$	$\frac{9}{32}$	16	$1\frac{1}{8}$	$\frac{59}{64}$	7	$2\frac{1}{2}$	$2\frac{1}{16}$	4
$\frac{7}{16}$	$\frac{21}{64}$	14	$1\frac{1}{4}$	$1\frac{3}{16}$	7	$2\frac{3}{4}$	$2\frac{5}{16}$	4
$\frac{1}{2}$	$\frac{25}{64}$	12	$1\frac{3}{8}$	$1\frac{1}{8}$	6	3	$2\frac{1}{2}$	$3\frac{1}{2}$
$\frac{9}{16}$	$\frac{29}{64}$	12	$1\frac{1}{2}$	$1\frac{17}{64}$	6	$3\frac{1}{4}$	$2\frac{3}{4}$	$3\frac{1}{2}$
$\frac{5}{8}$	$\frac{1}{2}$	11	$1\frac{5}{8}$	$1\frac{11}{32}$	5	$3\frac{1}{2}$	$2\frac{31}{32}$	$3\frac{1}{4}$
$\frac{11}{16}$	$\frac{9}{16}$	11	$1\frac{3}{4}$	$1\frac{15}{32}$	5	$3\frac{3}{4}$	$3\frac{3}{16}$	3
$\frac{3}{4}$	$\frac{19}{64}$	10	$1\frac{7}{8}$	$1\frac{19}{32}$	$4\frac{1}{2}$	4	$3\frac{27}{64}$	3

PLATE N.

SQUARE THREAD

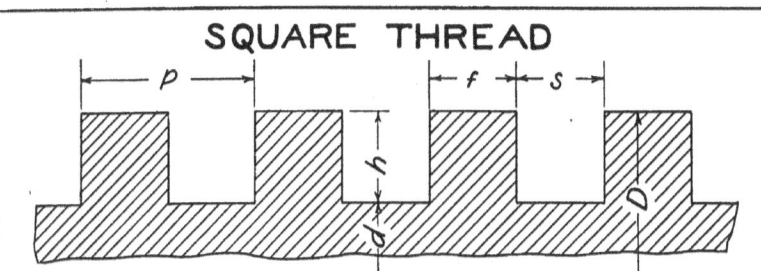

p = PITCH OF THREAD = 1 ÷ NO. OF THREADS PER INCH.
h = DEPTH OF THREAD = $\frac{p}{2}$, $f = s = \frac{p}{2}$
D = OUTSIDE DIAM.
d = EFFECTIVE DIAM. AT ROOT = $D - 2h = D - p$

DIAM OF SCREW	$\frac{1}{4}$	$\frac{5}{16}$	$\frac{3}{8}$	$\frac{7}{16}$	$\frac{1}{2}$	$\frac{5}{8}$	$\frac{3}{4}"$	$\frac{7}{8}$	1	$1\frac{1}{8}$	$1\frac{1}{4}$	$1\frac{3}{8}$	$1\frac{1}{2}$
THREADS PER INCH	10	9	8	7	6	$5\frac{1}{2}$	5	$4\frac{1}{2}$	4	$3\frac{1}{2}$	$3\frac{1}{2}$	3	3
DIAM OF SCREW	$1\frac{5}{8}$	$1\frac{3}{4}$	$1\frac{7}{8}$	2	$2\frac{1}{4}$	$2\frac{1}{2}$	$2\frac{3}{4}$	3	$3\frac{1}{4}$	$3\frac{1}{2}$	$3\frac{3}{4}$	4	
THREADS PER INCH	$2\frac{1}{2}$	$2\frac{1}{2}$	$2\frac{1}{4}$	$2\frac{1}{4}$	2	2	$1\frac{3}{4}$	$1\frac{3}{4}$	$1\frac{5}{8}$	$1\frac{5}{8}$	$1\frac{1}{2}$	$1\frac{1}{2}$	

ACME STANDARD THREAD

p = PITCH OF THREAD = 1 ÷ NO. OF THREADS PER INCH.
D = OUTSIDE DIAM. OF SCREW. d = DIAM. OF SCREW AT ROOT.

NUMBER OF THREADS PER INCH	h DEPTH OF THREAD	f WIDTH AT POINT
1	.5100	.3707
1⅓	.3850	.2780
2	.2600	.1853
3	.1767	.1235
4	.1350	.0927
5	.1100	.0741
6	.0933	.0618
7	.0814	.0529
8	.0725	.0463
9	.0655	.0413
10	.0600	.0371

h = DEPTH OF THREAD = $\frac{1}{2 \times \text{NO. THDS. PER IN.}} + .01$

$d = D - 2h = D - \frac{1}{\text{NO. OF THDS PER IN}} + .02$

f = WIDTH AT POINT = $\frac{.3707}{\text{NO. OF THDS. PER IN.}}$

TO DRAW THE ACME THREAD, FIRST LAYOFF THE SUCCESSIVE PITCHES, FROM THESE POINTS MARK OFF THE POINT WIDTHS f. THROUGH THE TWO SETS OF POINTS THUS FOUND DRAW LINES AT 30 AS SHOWN. THIS IS SUFFICIENTLY CLOSE FOR A DRAWING.

PLATE O.

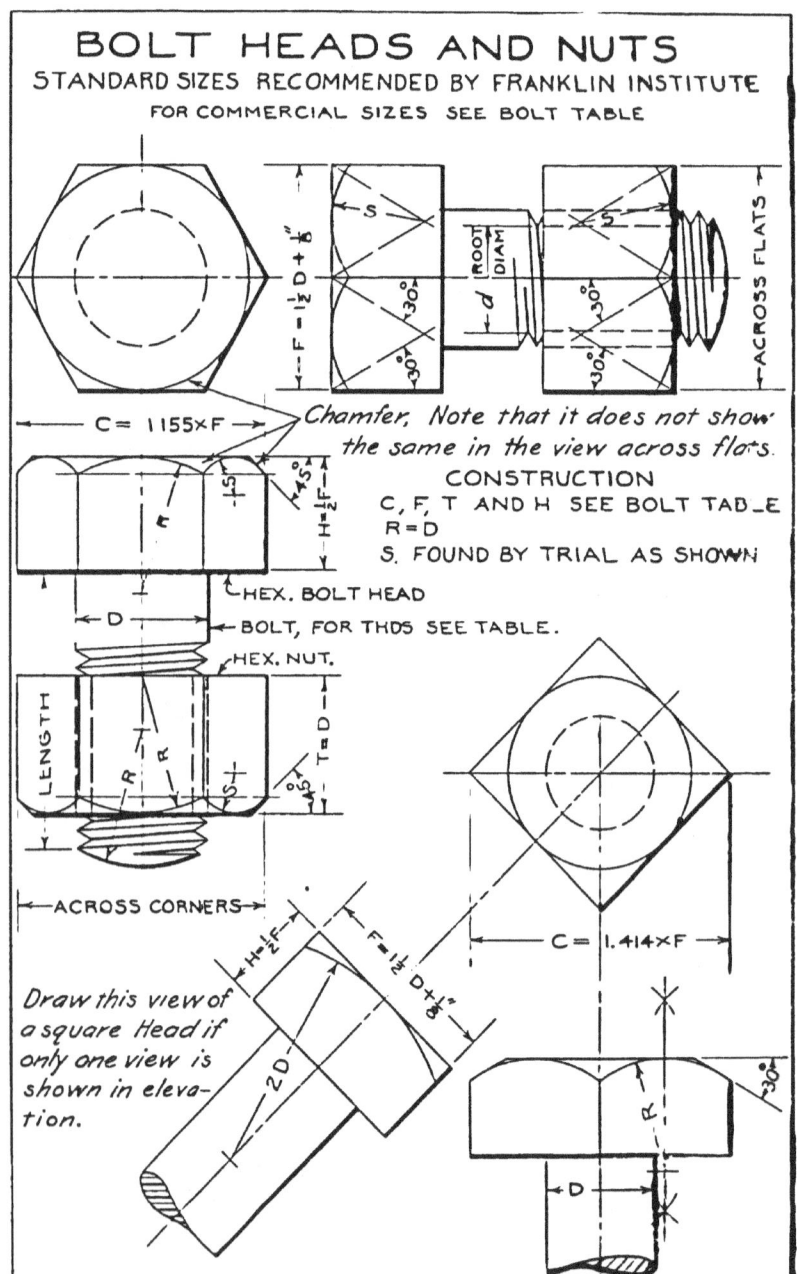

PROPORTIONS FOR U.S. STANDARD SCREW THREADS AND NUTS

HOOPES AND TOWNSEND'S STANDARD SIZES FOR BOLT HEADS

DIAM OF BOLT D	BOLT THREADS			NUTS				HEADS			
	THDS. PER INCH N	DIAM. AT ROOT d	AREA AT ROOT A	THICK HEX. OR SQ. T	HEX. LONG DIAM. C	SQ. LONG DIAM. C	HEX, SQ. SHORT DIAM. F	HEX. OR SQ. SHORT DIAM. F	THICK H	COUNTERSUNK DIAM. K	THICK H
$\frac{1}{4}$	20	.185	.026	$\frac{1}{4}$	$\frac{37}{64}$	$\frac{45}{64}$	$\frac{1}{2}$	$\frac{3}{8}$	$\frac{3}{16}$	$\frac{1}{2}$	$\frac{1}{8}$
$\frac{5}{16}$	18	.240	.045	$\frac{5}{16}$	$\frac{11}{16}$	$\frac{27}{32}$	$\frac{19}{32}$	$\frac{15}{32}$	$\frac{15}{64}$	$\frac{9}{16}$	$\frac{3}{16}$
$\frac{3}{8}$	16	.294	.067	$\frac{3}{8}$	$\frac{51}{64}$	$\frac{63}{64}$	$\frac{11}{16}$	$\frac{9}{16}$	$\frac{9}{32}$	$\frac{11}{16}$	$\frac{3}{16}$
$\frac{7}{16}$	14	.344	.092	$\frac{7}{16}$	$\frac{7}{8}$	$1\frac{7}{64}$	$\frac{25}{32}$	$\frac{21}{32}$	$\frac{21}{64}$	$\frac{3}{4}$	$\frac{7}{16}$
$\frac{1}{2}$	13	.400	.125	$\frac{1}{2}$	1	$1\frac{15}{64}$	$\frac{7}{8}$	$\frac{3}{4}$	$\frac{3}{8}$	$\frac{7}{8}$	$\frac{1}{4}$
$\frac{9}{16}$	12	.454	.161	$\frac{9}{16}$	$1\frac{1}{8}$	$1\frac{23}{64}$	$\frac{31}{32}$	$\frac{27}{32}$	$\frac{27}{64}$	$\frac{15}{16}$	$\frac{1}{4}$
$\frac{5}{8}$	11	.507	.201	$\frac{5}{8}$	$1\frac{7}{32}$	$1\frac{1}{2}$	$1\frac{1}{16}$	$\frac{15}{16}$	$\frac{15}{32}$	$1\frac{1}{8}$	$\frac{1}{4}$
$\frac{3}{4}$	10	.620	.301	$\frac{3}{4}$	$1\frac{7}{16}$	$1\frac{49}{64}$	$1\frac{1}{4}$	$1\frac{1}{8}$	$\frac{9}{16}$	$1\frac{1}{4}$	$\frac{3}{8}$
$\frac{7}{8}$	9	.731	.419	$\frac{7}{8}$	$1\frac{21}{32}$	$2\frac{1}{32}$	$1\frac{7}{16}$	$1\frac{5}{16}$	$\frac{21}{32}$	$1\frac{3}{8}$	$\frac{7}{16}$
1	8	.837	.550	1	$1\frac{7}{8}$	$2\frac{19}{64}$	$1\frac{5}{8}$	$1\frac{1}{2}$	$\frac{3}{4}$	$1\frac{5}{8}$	$\frac{1}{2}$
$1\frac{1}{8}$	7	.940	.693	$1\frac{1}{8}$	$2\frac{3}{32}$	$2\frac{9}{16}$	$1\frac{13}{16}$	$1\frac{11}{16}$	$\frac{27}{32}$		
$1\frac{1}{4}$	7	1.065	.890	$1\frac{1}{4}$	$2\frac{5}{16}$	$2\frac{53}{64}$	2	$1\frac{7}{8}$	$\frac{15}{16}$		
$1\frac{3}{8}$	6	1.160	1.056	$1\frac{3}{8}$	$2\frac{17}{32}$	$3\frac{3}{32}$	$2\frac{3}{16}$	$2\frac{1}{16}$	$1\frac{1}{32}$		
$1\frac{1}{2}$	6	1.284	1.294	$1\frac{1}{2}$	$2\frac{3}{4}$	$3\frac{23}{64}$	$2\frac{3}{8}$	$2\frac{1}{4}$	$1\frac{1}{8}$		
$1\frac{5}{8}$	$5\frac{1}{2}$	1.389	1.515	$1\frac{5}{8}$	$2\frac{31}{32}$	$3\frac{5}{8}$	$2\frac{9}{16}$	$2\frac{7}{16}$	$1\frac{7}{32}$		
$1\frac{3}{4}$	5	1.491	1.746	$1\frac{3}{4}$	$3\frac{3}{16}$	$3\frac{57}{64}$	$2\frac{3}{4}$	$2\frac{5}{8}$	$1\frac{5}{16}$		
$1\frac{7}{8}$	5	1.616	2.051	$1\frac{7}{8}$	$3\frac{13}{32}$	$4\frac{5}{32}$	$2\frac{15}{16}$	$2\frac{13}{16}$	$1\frac{13}{32}$		
2	$4\frac{1}{2}$	1.712	2.301	2	$3\frac{5}{8}$	$4\frac{27}{64}$	$3\frac{1}{8}$	3	$1\frac{1}{2}$		
$2\frac{1}{4}$	$4\frac{1}{2}$	1.962	3.023	$2\frac{1}{4}$	$4\frac{1}{16}$	$4\frac{61}{64}$	$3\frac{1}{2}$				
$2\frac{1}{2}$	4	2.176	3.718	$2\frac{1}{2}$	$4\frac{1}{2}$	$5\frac{31}{64}$	$3\frac{7}{8}$				
$2\frac{3}{4}$	4	2.426	4.622	$2\frac{3}{4}$	$4\frac{29}{32}$	6	$4\frac{1}{4}$				
3	$3\frac{1}{2}$	2.629	5.428	3	$5\frac{3}{8}$	$6\frac{17}{32}$	$4\frac{5}{8}$				
$3\frac{1}{4}$	$3\frac{1}{2}$	2.879	6.509	$3\frac{1}{4}$	$5\frac{13}{16}$	$7\frac{1}{16}$	5				
$3\frac{1}{2}$	$3\frac{1}{4}$	3.100	7.547	$3\frac{1}{2}$	$6\frac{7}{64}$	$7\frac{39}{64}$	$5\frac{3}{8}$				
$3\frac{3}{4}$	3	3.318	8.641	$3\frac{3}{4}$	$6\frac{21}{32}$	$8\frac{1}{8}$	$5\frac{3}{4}$				
4	3	3.567	9.993	4	$7\frac{3}{32}$	$8\frac{41}{64}$	$6\frac{1}{8}$				

REGULAR SQ. HEAD CUP OR ROUND POINT
THREADS U.S. STANDARD
F=H, SAME AS DIAM. OF SCREW.
DIAMETERS FROM $\frac{1}{4}''$ TO $1\frac{1}{4}''$
LENGTH UNDER HEAD= L
VARIES FROM $\frac{3}{4}''$ TO 5''

IRON SET SCREWS

PLATE Q.

STANDARD MACHINE SCREWS
AMERICAN SCREW COMPANY

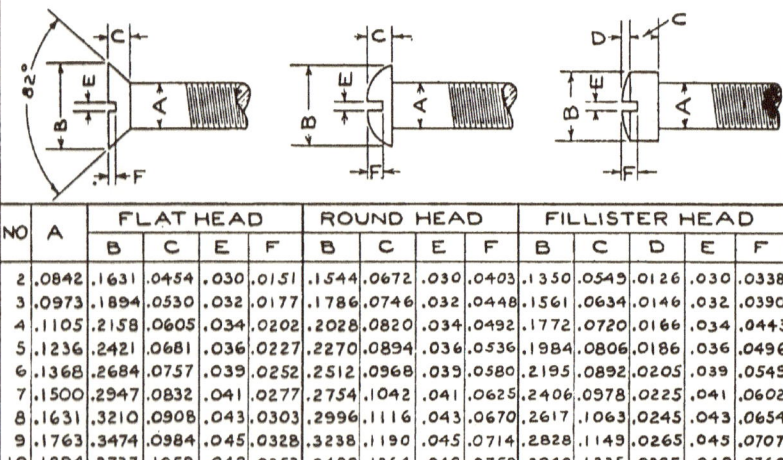

NO	A	FLAT HEAD				ROUND HEAD				FILLISTER HEAD				
		B	C	E	F	B	C	E	F	B	C	D	E	F
2	.0842	.1631	.0454	.030	.0151	.1544	.0672	.030	.0403	.1350	.0549	.0126	.030	.0338
3	.0973	.1894	.0530	.032	.0177	.1786	.0746	.032	.0448	.1561	.0634	.0146	.032	.0390
4	.1105	.2158	.0605	.034	.0202	.2028	.0820	.034	.0492	.1772	.0720	.0166	.034	.0443
5	.1236	.2421	.0681	.036	.0227	.2270	.0894	.036	.0536	.1984	.0806	.0186	.036	.0496
6	.1368	.2684	.0757	.039	.0252	.2512	.0968	.039	.0580	.2195	.0892	.0205	.039	.0549
7	.1500	.2947	.0832	.041	.0277	.2754	.1042	.041	.0625	.2406	.0978	.0225	.041	.0602
8	.1631	.3210	.0908	.043	.0303	.2996	.1116	.043	.0670	.2617	.1063	.0245	.043	.0654
9	.1763	.3474	.0984	.045	.0328	.3238	.1190	.045	.0714	.2828	.1149	.0265	.045	.0707
10	.1894	.3737	.1059	.048	.0353	.3480	.1264	.048	.0758	.3040	.1235	.0285	.048	.0760
12	.2158	.4263	.1210	.052	.0403	.3922	.1412	.052	.0847	.3462	.1407	.0324	.052	.0866
14	.2421	.4790	.1362	.057	.0454	.4364	.1560	.057	.0936	.3884	.1578	.0364	.057	.0971
16	.2684	.5316	.1513	.061	.0504	.4806	.1708	.061	.1024	.4307	.1750	.0403	.061	.1077
18	.2947	.5842	.1665	.066	.0555	.5248	.1856	.066	.1114	.4729	.1921	.0443	.066	.1182
20	.3210	.6368	.1816	.070	.0605	.5690	.2004	.070	.1202	.5152	.2093	.0483	.070	.1288
22	.3474	.6895	.1967	.075	.0656	.6106	.2152	.075	.1291	.5574	.2267	.0520	.075	.1384
24	.3737	.7421	.2118	.079	.0706	.6522	.2300	.079	.1380	.5996	.2436	.0562	.079	.1499
26	.4000	.7421	.1967	.084	.0656	.6938	.2448	.084	.1469	.6419	.2608	.0601	.084	.1605
28	.4263	.7948	.2118	.088	.0706	.7354	.2596	.088	.1558	.6841	.2779	.0641	.088	.1710
30	.4526	.8474	.2270	.093	.0757	.7770	.2744	.093	.1646	.7264	.2951	.0681	.093	.1816

MACHINE SCREWS ARE DESIGNATED THUS—"#12×20 FILLISTER HEAD MACHINE SCREWS" WHICH MEANS SIZE (GAUGE) #12 HAVING 20 THREADS PER INCH THEREON. SEE LAST COLUMN IN THE TABLE OF STANDARDS FOR WIRE GAUGES.
THE NUMBER OF THREADS PER INCH FOR THE VARIOUS SIZES WILL BE FOUND IN THE FOLLOWING TABLE.

NO	THREADS PER INCH						NO	THREADS PER INCH					
2	64	56	48	12	24	20	
3	..	56	48	14	24	20	18	
4	40	36	32	16	..	20	18	16	..	
5	40	36	32	18	..	20	18	16	..	
6	36	32	30.	20	18	16	..
7	32	30	..	22	18	16	..
8	36	32	30	..	24	18	16	14
9	32	30	24	26	16	14
10	32	30	24	28	16	14
							30	16	14	

PLATE R.

TAPERS. 1. When it is desired that two or more pieces shall fit tightly and at the same time be readily adjustable for taking up wear or for removing, one or more of the pieces are made tapering.

2. The necessary dimensions are those of the larger end, the length of the tapered portion and the taper per foot, or fraction of an inch in a whole number of inches, i. e., $\frac{1}{4}''$ in $5''$. (See Fig. 33.)

3. On a tapered piece, that does not fit anything, give the size at each end and its length. The rate of taper must not be given.

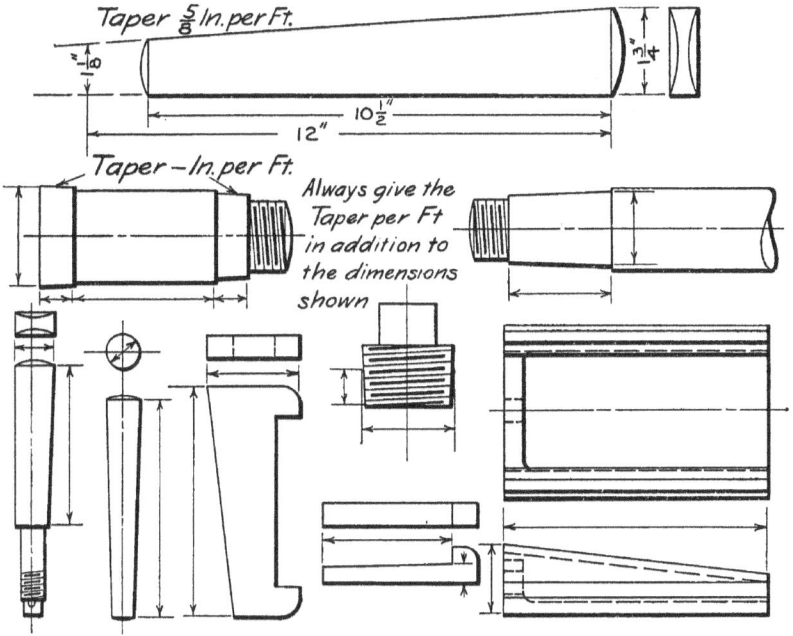

Fig. 33.

4. There is no universal standard for tapers, different lines of work and different shops adopt tapers suitable to their requirements. The following, used in locomotive practice, is a fair sample:
Bolt Taper $\frac{1}{16}''$ in $12''$. Boiler Taps $1''$ in $12''$.
Cross-head Pins $\frac{1}{4}''$ in $5''$. Brass Cock Plug $2\frac{1}{4}''$ in $12''$.
Cross-head Key $\frac{3}{4}''$ in $8''$. Cross-head End of Piston Rod $\frac{1}{4}''$ in $5''$.
Connecting Rod, Stub Keys and Cotters $\frac{3}{4}''$ in $12''$.

STANDARD STEEL TAPER PINS. 1. These pins, made by Pratt and Whitney Co., taper $\frac{1}{4}''$ per foot, and lengths vary by $\frac{1}{4}''$.

Size No.	0	1	2	3	4	5	6	7	8	9	10
Large Diam.	0.156	0.172	0.193	0.219	0.250	0.289	0.341	0.409	0.492	0.591	0.706
Length	$\frac{3}{4}$-1	$\frac{3}{4}$-1$\frac{1}{4}$	$\frac{3}{4}$-1$\frac{1}{2}$	$\frac{3}{4}$-1$\frac{3}{4}$	$\frac{3}{4}$-2	$\frac{3}{4}$-2$\frac{1}{4}$	$\frac{3}{4}$-3$\frac{1}{4}$	1-3$\frac{3}{4}$	1$\frac{1}{4}$-4$\frac{1}{2}$	1$\frac{1}{2}$-5$\frac{1}{4}$	1$\frac{1}{2}$-6

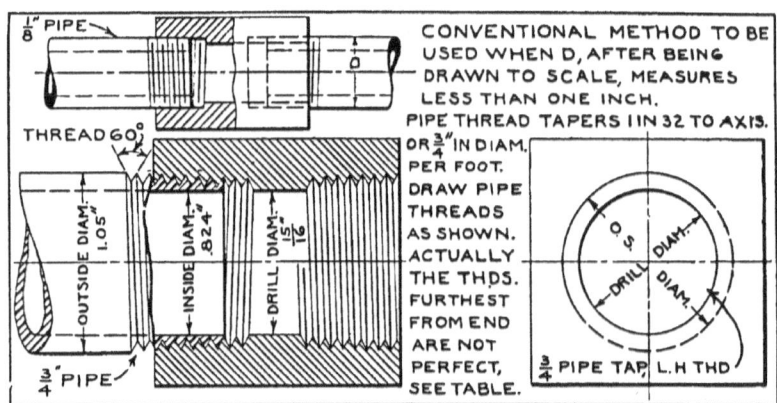

WROUGHT IRON STEAM, GAS AND WATER PIPE
NATIONAL TUBE COMPANY — STANDARD DIMENSIONS

NOMINAL INTERNAL	DIAMETERS ACTUAL INTERNAL STANDARD	DIAMETERS ACTUAL INTERNAL EXTRA HEAVY	DIAMETERS ACTUAL EXTERNAL	TRANSVERSE INTERNAL AREAS STANDARD	TRANSVERSE INTERNAL AREAS EXTRA HEAVY	THREADS NO PER INCH	THREADS LENGTH THREADED	THREADS LENGTH PERFECT AT ROOT	DRILL HOLE FOR TAP
1/8	.270	.205	.405	.057	.033	27	9/32	3/16	21/64
1/4	.364	.294	.540	.104	.068	18	3/8	9/32	29/64
3/8	.494	.421	.675	.191	.139	18	7/16	19/64	19/32
1/2	.623	.542	.840	.304	.231	14	1/2	3/8	23/32
3/4	.824	.736	1.050	.533	.425	14	9/16	13/32	15/16
1	1.048	.951	1.315	.861	.710	11 1/2	5/8	1/2	1 3/16
1 1/4	1.380	1.272	1.660	1.496	1.271	11 1/2	11/16	35/64	1 15/32
1 1/2	1.611	1.494	1.900	2.036	1.753	11 1/2	13/16	9/16	1 23/32
2	2.067	1.933	2.375	3.356	2.935	11 1/2	7/8	37/64	2 3/16
2 1/2	2.468	2.315	2.875	4.780	4.209	8	1	7/8	2 9/16
3	3.067	2.892	3.500	7.383	6.569	8	1	15/16	3 5/16
3 1/2	3.548	3.358	4.000	9.887	8.856	8	1 1/16	1	3 13/16
4	4.026	3.818	4.500	12.730	11.449	8	1 1/8	1 3/64	4 5/16
4 1/2	4.508	4.280	5.000	15.961	14.387	8	1 1/4	1 7/64	4 13/16
5	5.045	4.813	5.563	19.985	18.193	8	1 1/4	1 5/32	5 3/8
6	6.065	5.751	6.625	28.886	25.976	8	1 3/8	1 1/4	6 3/8
7	7.023	6.625	7.625	38.743	34.472	8	1 1/2	1 3/8	7 7/16
8	7.982	7.625	8.625	50.021	45.664	8	1 5/8	1 7/16	8 7/16
9	8.937	8.625	9.625	62.722	58.426	8	1 5/8	1 13/16	9 3/8
10	10.019	9.750	10.750	78.822	74.662	8	1 3/4	1 11/16	10 15/32
11	11.000	11.750	95.034	8	1 7/8	1 3/4	11 7/16
12	12.000	11.750	12.750	113.090	108.430	8	1 7/8	1 3/4	12 7/16

PLATE S.

PIPE. 1. Iron pipe is always specified by its nominal internal diameter. By referring to the pipe table it will be seen that the actual sizes differ from the nominal. Use actual sizes on drawings.

2. A pipe tapped hole is shown in plan by two circles, the inner one being full and equal to the drill size, the outer one half full and half dotted and equal to the outside diameter of the pipe. (See illustration on Plate S.)

3. Tubes of iron, steel, brass or copper are specified by their outside diameter and the gauge number corresponding to the thickness of the material; thus 2″ brass tube 12 B. & S. gauge.

STANDARD GAUGES. 1. Standard gauges for Wire, Plate and Screws are given in Plate T.

WEIGHTS OF CASTINGS AND FORGINGS. It is often required to find the approximate weight of a piece of machinery, especially for making estimates from drawings. This is done by finding the volume and multiplying by the specific weight of the material of which it is to be made. As results within 10 % of actual weight are considered satisfactory in practice, it is not

WEIGHTS OF METALS

ALUMINUM	WEIGHS .094#	PER CU. IN.
BRASS	" .30#	" "
BRONZE AND COPPER	" .31#	" "
CAST IRON	" .26#	" "
CAST STEEL	" .28#	" "
LEAD	" .41#	" "
WROUGHT IRON AND STEEL	" .28#	" "

LET A = AREA OF CROSS SECTION OF A FILLET
$A = C - B \quad C = R^2 \quad B = \dfrac{\pi R^2}{4}$
$A = C - B = R^2 - \dfrac{\pi R^2}{4} = R^2 - .7854 R^2 = R^2(1 - .7854)$
THEREFORE $A = .2146 R^2 = .2 R^2$ APPROXIMATELY

Fig. 34.

necessary to consider small fillets and other minute details. Divide the piece into a number of parts, the volumes of which are readily obtainable. If close estimating is required or if there are numerous fillets of some size, they should be taken into account. (See Fig. 34.)

| STANDARDS FOR WIRE GAUGES IN USE IN THE UNITED STATES DIMENSIONS ARE IN DECIMAL PARTS OF AN INCH ||||||| |
|---|---|---|---|---|---|---|
| NUMBER OF WIRE GAUGE | AMERICAN OR BROWN AND SHARPE | BIRMINGHAM OR STUBS ENGLISH | STUBS STEEL WIRE | U.S. STANDARD FOR PLATE | NUMBER OF SCREW OR WIRE GAUGE | MACHINE AND WOOD SCREW GAUGE |
| 000000 | | | | .4688 | 000000 | |
| 00000 | | | | .4375 | 00000 | |
| 0000 | .46 | .454 | | .4063 | 0000 | |
| 000 | .4096 | .425 | | .3750 | 000 | .0315 |
| 00 | .3648 | .38 | | .3438 | 00 | .0447 |
| 0 | .3249 | .34 | | .3125 | 0 | .0578 |
| 1 | .2893 | .3 | .227 | .2813 | 1 | .0710 |
| 2 | .2576 | .284 | .219 | .2656 | 2 | .0842 |
| 3 | .2294 | .259 | .212 | .25 | 3 | .0973 |
| 4 | .2043 | .238 | .207 | .2344 | 4 | .1105 |
| 5 | .1819 | .22 | .204 | .2188 | 5 | .1236 |
| 6 | .1620 | .203 | .201 | .2031 | 6 | .1368 |
| 7 | .1443 | .18 | .199 | .1875 | 7 | .1500 |
| 8 | .1285 | .165 | .197 | .1719 | 8 | .1631 |
| 9 | .1144 | .148 | .194 | .1563 | 9 | .1763 |
| 10 | .1019 | .134 | .191 | .1406 | 10 | .1894 |
| 11 | .0907 | .12 | .188 | .125 | 11 | .2026 |
| 12 | .0808 | .109 | .185 | .1094 | 12 | .2158 |
| 13 | .0720 | .095 | .182 | .0938 | 13 | .2289 |
| 14 | .0641 | .083 | .180 | .0781 | 14 | .2421 |
| 15 | .0571 | .072 | .178 | .0703 | 15 | .2552 |
| 16 | .0508 | .065 | .175 | .0625 | 16 | .2684 |
| 17 | .0453 | .058 | .172 | .0563 | 17 | .2816 |
| 18 | .0403 | .049 | .168 | .05 | 18 | .2947 |
| 19 | .0359 | .042 | .164 | .0438 | 19 | .3079 |
| 20 | .0320 | .035 | .161 | .0375 | 20 | .3210 |
| 21 | .0285 | .032 | .157 | .0344 | 21 | .3342 |
| 22 | .0253 | .028 | .155 | .0313 | 22 | .3474 |
| 23 | .0226 | .025 | .153 | .0281 | 23 | .3605 |
| 24 | .0201 | .022 | .151 | .025 | 24 | .3737 |
| 25 | .0179 | .02 | .148 | .0219 | 25 | .3868 |
| 26 | .0159 | .018 | .146 | .0188 | 26 | .4000 |
| 27 | .0142 | .016 | .143 | .0172 | 27 | .4132 |
| 28 | .0126 | .014 | .139 | .0156 | 28 | .4263 |
| 29 | .0113 | .013 | .134 | .0140 | 29 | .4395 |
| 30 | .0100 | .012 | .127 | .0125 | 30 | .4526 |
| 31 | .0089 | .01 | .120 | .0109 | 31 | .4658 |
| 32 | .0080 | .009 | .115 | .0102 | 32 | .4790 |
| 33 | .0071 | .008 | .112 | .0094 | 33 | .4921 |
| 34 | .0063 | .007 | .110 | .0086 | 34 | .5053 |
| 35 | .0056 | .005 | .108 | .0078 | 35 | .5184 |
| 36 | .005 | .004 | .106 | .0070 | 36 | .5316 |
| 37 | .0045 | | .103 | .0066 | 37 | .5448 |
| 38 | .0040 | | .101 | .0063 | 38 | .5579 |
| 39 | .0035 | | .099 | | 39 | .5711 |
| 40 | .0031 | | .097 | | 40 | .5842 |

PLATE T.

DECIMALS OF AN INCH FOR EACH 64TH

32NDS.	64THS.	DECIMAL	FRACTION	32NDS.	64THS.	DECIMAL	FRACTION
	1	.015625			33	.515625	
1	2	.03125		17	34	.53125	
	3	.046875			35	.546875	
2	4	.0625	1–16	18	36	.5625	9–16
	5	.078125			37	.578125	
3	6	.09375		19	38	.59375	
	7	.109375			39	.609375	
4	8	.125	1–8	20	40	.625	5–8
	9	.140625			41	.640625	
5	10	.15625		21	42	.65625	
	11	.171875			43	.671875	
6	12	.1875	3–16	22	44	.6875	11–16
	13	.203125			45	.703125	
7	14	.21875		23	46	.71875	
	15	.234375			47	.734375	
8	16	.25	1–4	24	48	.75	3–4
	17	.265625			49	.765625	
9	18	.28125		25	50	.78125	
	19	.296875			51	.796875	
10	20	.3125	5–16	26	52	.8125	13–16
	21	.328125			53	.828125	
11	22	.34375		27	54	.84375	
	23	.359375			55	.859375	
12	24	.375	3–8	28	56	.875	7–8
	25	.390625			57	.890625	
13	26	.40625		29	58	.90625	
	27	.421875			59	.921875	
14	28	.4375	7–16	30	60	.9375	15–16
	29	.453125			61	.953125	
15	30	.46875		31	62	.96875	
	31	.484375			63	.984375	
16	32	.5	1–2	32	64	1.	1

PLATE U.

INDEX.

	PAGE		PAGE
Abbreviations—Fig. 18	19	Machine Screws—Plate R	51
Arrangements of Views—Fig. 8, Fig. 9.	9	Number Circle—Fig. 4	7
Arrow Heads—Fig. 16, Fig. 17	17	Pipe—Plate S	59
Assembly Drawings	39	Preface	3
Bill of Materials—Plate G	34	Screw Threads—Fig. 28, Fig. 29, Fig. 30	48
Blue-prints	41		
Bolts—Plates P, Q	51	Screw Threads. Proportions and Tables—Plates N, O	51
Choosing the Proper Scale—Fig. 10	11		
Conventional Threads—Fig. 32	50	Sections—Fig. 15	19
Courses	4	Shade Lines—Fig. 14	14
Cross-hatching—Fig. 20, Plate A	20	Size of Sheets—Fig. 5, Fig. 6	7
Decimal Equivalents—Plate U	61	Sketches—Fig. 26, Fig. 27	41
Department Standard Sizes, Fig 7,	8	Sub-Captions—Plate G	34
Dimensioning—Fig. 16, Fig. 17	17	Tabulated Dimensions—Plate J	18
Erecting Drawings	40	Tapers—Fig. 33	57
Extension Lines	18	Taper Pins, Standard	57
Figures—Fig. 16	17	Tapped Holes—Fig. 31	50
Finish Marks—Fig. 19	19	The Essentials	9
Fractions—Fig. 16	17	Tinting	22
Gears—Plates L, M	45	Titles—Plate F, G, H, K	34
Inking In	15	Tracings	40
Instruments—Fig. 1, Fig. 2, Fig. 3,	5	Trimming Drawings	9
Intersections—Fig. 22, Fig. 23	29	Weights of Castings and Forgings—Fig. 34	59
Lettering—Fig. 24, Fig. 25, Plate E	33		
Line Shading—Fig. 21, Plates B, C, D	23		
Lines—Fig. 11, Fig. 12, Fig. 13	12	Wire and Screw Gauges—Plate T	59

LIST OF ILLUSTRATIONS.

FIGURE	PAGE
1—Instruments in Case	5
2—Irregular Curve	6
3—Use of Triangles	6
4—Number Circle	7
5—Size of Sheets, Course 492, first term	7
6—Size of Sheets, Course 492, second term	8
" 493, first term	8
7—Size of Department Standard Drawings	9
8—Object Surrounded by Planes	10
9—Position of Views	10
10—Locating Views	11
11—Lines	12
12—Dotted Lines. (Ending)	12
13—Piston	13
14—Shade Lines	14
15—Coupling	16
16—Size of Figures and Arrows	17
17—Dimensioning Small Spaces	18
18—Abbreviations and Symbols	19
19—Finish Marks	19
20—Breaks in Long Pieces	22
21—Line Shading. (Theory)	24
22—Intersection of Cylinders	29
23—Intersection of Elbow and Cylinder	31
24—Block Letters	33
25—Sixty degree Letters. (Course 492)	33
26—Sketch	39
27—Sketch. (Details)	40

FIGURE	PAGE
28—Screw Thread. (Helix)	48
29—Screw Threads. (R & L, V & Sq.)	49
30—Section Through Threads	49
31—Tapped Hole	50
32—Conventional Threads	50
33—Tapers	57
34—Weights of Metals	59

PLATE	
A—Conventional Standard Cross-hatchings	21
B—Line Shading. (Examples)	26
C—Line Shading. "	27
D—Line Shading. "	28
E—Lettering	32
F—Titles. (General)	35
G—Titles, Sub-Captions, Bill of Materials	36
H—Titles. (Course 517)	37
J—Tabulated Dimensions	38
K—Titles. (Course 494, second term)	39
L—Drawing the Involute Tooth	46
M—Drawing Bevel Gears	47
N—U. S. & V. Standard Threads. (Proportions)	52
O—Square and Acme Standard Threads (Proportions)	53
P—Bolt Heads and Nuts	54
Q—U. S. Screw Threads and Nuts	55
R—Machine Screws	56
S—Pipe Table	58
T—Wire and Screw Gauges	60
U—Decimal Equivalents	61

www.ingramcontent.com/pod-product-compliance
Lightning Source LLC
Chambersburg PA
CBHW020931180526
45163CB00007B/2971